DRAWING
HANDBOOK
DAVID WEBB

DRAWING
HANDBOOK

DAVID WEBB

MATERIALS • TECHNIQUES • THEORY

D&C
David and Charles

A DAVID & CHARLES BOOK
Copyright © David & Charles Limited 2008

David & Charles is an F+W Publications Inc.
company
4700 East Galbraith Road
Cincinnati, OH 45236

First published in the UK in 2008
First published in the US in 2008

A catalogue record for this book is
available from the British Library.

ISBN-13: 978-0-7153-2653-4 flexi
ISBN-10: 0-7153-2653-8 flexi

Printed in Singapore by KHL Printing Co Pte
Ltd. for David & Charles
Brunel House Newton Abbot Devon

Senior Commissioning Editor:
Freya Dangerfield
Editorial Manager: Emily Pitcher
Editor: Verity Muir
Photographer: Kim Sayer
Art Editor: Martin Smith
Production Controller: Kelly Smith

Visit our website at
www.davidandcharles.co.uk

David & Charles books are available from all
good bookshops; alternatively you can contact
our Orderline on 0870 9908222
or write to us at FREEPOST EX2 110, D&C
Direct, Newton Abbot, TQ12 4ZZ (no
stamp required UK only); US customers call
800-289-0963 and Canadian customers call
800-840-5220.

PRODUCT CREDITS

Pentel (pencils) pp 11, 13; Derwent (pencils) p1?
Caran d'Ache (graphite sticks) p14; L. Cornelisse
and Son (graphite powder) p15; Unison (soft
pastels) pp 10, 11, 28, 29, 63; EF (sketching per
p35; Faber Castell (PITT artist pen) p36;
FW (liquid acrylic) pp 40, 41; Colorex p41; Pente
(Hybrid Gel) pp 44, 45; Winsor and Newton
(oilbar) pp 50, 51; Sansodor (low odour solvent
p59.

The publishers would like to thank the
following for supplying materials for the
artist to use and for photography.

Graphite and coloured pencils, watercolour
pencils and charcoal pencils:

The Cumberland Pencil Company,
Derwent House, Jubilee Road,
Lillyhall Business Park, Workington,
Cumbria CA14 4HS
Tel: 01900 609590
Website: www.pencils.co.uk

Felt pens, brush pens and gel pens:

Pentel (Stationery) Ltd,
Hunts Rise,
South Marston Park,
Swindon, SN3 4TW
Tel: 01793 823333
www.pentel.co.uk

Watercolour and drawing papers:

St Cuthbert's Mill – Inveresk Plc,
Haybridge,
Wells,
Somerset BA5 1AG
Tel: 01749 672015
Email: inveresk.co.uk
artistpapers@inveresk.co.uk

Soft pastels:

Unison Colour Ltd,
Thorneyburn,
Tarset,
Northumberland NE48 1NA
Tel: 01434 240203
Email: unisoncolour@btconnect.com

Thanks for the loan of equipment and
materials for photography are also due:

Harberton Art Workshop,
27 High Street,
Totnes, TQ9 5NP.
Tel: 01803 862390

CONTENTS

Introduction

Drawing can be defined as the picturing of objects on a surface, and as such anyone can draw. This spontaneous childhood activity is often dropped as we grow up and become more critical of our efforts – the gulf between what we can see and what we can draw seems too great and we give up in frustration. Drawing, however, can be learned and, as with most things, practise improves our skill even if it does not always achieve perfection.

Start by setting aside a short time each day for drawing. Always carry a small sketchbook and pencil with you and fill in the odd five or ten minutes by drawing anything you can see around you. Look at the scene or the object and draw what you see, rather than what you expect the subject to look like. Use exercises, such as drawing negative spaces, to make you look really hard at creating what is in front of you. As you improve, try to build up a collection of references for future compositions; aim to capture a movement, the essentials of an object, an interesting juxtaposition of elements in a scene. Your sketchbooks will soon become an invaluable resource.

Once you get hooked on drawing you will want to experiment with the many different media available. The physical differences between using crumbly charcoal,

powdery pastels and greasy oil sticks will dictate what you draw and how you apply them to the support. For fine detail, pencils of all kinds, pens and ball-points cannot be bettered. Working large with bold sweeps and strong lines needs drawing tools such as charcoal, felt-tip pens or pastels. Some drawing media can be erased easily, others stain the paper; some demand you work quickly and confidently, while others are capable of delicate, precise lines where just a suggestion is enough to create an interesting image. What you draw on is as important as choosing what to draw with and matching the medium to the support can be the key to a successful picture.

Drawing accurately is not the only skill. Creating an impression or a feeling is equally important. When drawing from life try to work on the picture as a whole rather than concentrating on a small area. Use a variety of lines – fine and light or dark and heavy, continuous or sketchy – to keep the drawing interesting and lively. Introducing contour lines, building up the shading or adding a wash will make the composition three dimensional.

It is never too late to start drawing, the materials are as cheap or as expensive as you choose and the subject matter is all around you. Now pick up a pencil and begin. Keep your old sketchbooks and first drawings and after a few months look back to see how much you have improved.

How to use this book

The first section of this book introduces the wealth of
drawing material available.

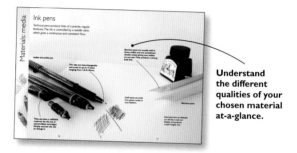

**Understand
the different
qualities of your
chosen material
at-a-glance.**

The second section explores the various drawing
techniques that can be used with these materials.

**Different
techniques are
explained and
illustrated.**

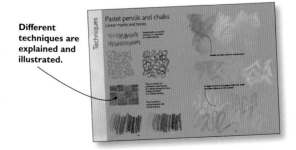

This is followed by some examples of exciting ways of combining media; choice is critical.

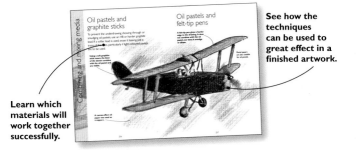

See how the techniques can be used to great effect in a finished artwork.

Learn which materials will work together successfully.

Underpinning every successful drawing is a knowledge of colour theory, perspective and the basic rules of composition – all are aids to help you to create your masterpiece and are clearly explained in the last section of the book.

The key to successful drawing is knowledge of colour theory, perspective and the basic rules of composition.

Use this section as the foundation of your drawing knowledge, or to refresh your memory.

MATERIALS

From paper types to coloured pencils, chalks, pastels, and pen and ink, this section is an invaluable reference to all of the drawing materials available today and how to use them to achieve the best effects.

Graphite pencils

Made from powdered graphite mixed with china clay, graphite pencil leads vary in hardness depending on the the amount of clay used.

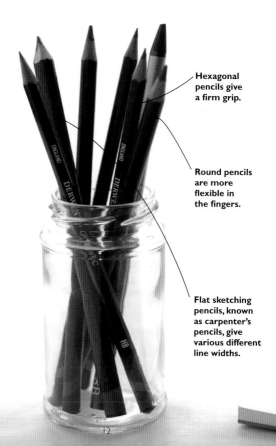

Hexagonal pencils give a firm grip.

Round pencils are more flexible in the fingers.

Flat sketching pencils, known as carpenter's pencils, give various different line widths.

Use tear-off pads of glass-paper to sharpen pencil points.

Water-soluble graphite pencils

8B

Water-soluble graphite sticks

The leads for clutch pencils come in the same degrees of hard to soft.

Carpenter's pencil

ENGLAND

ENGLAND

ENGLAND

Graphite pencils – soft to hard

Pencils are available in grades H to 9H, which is the hardest, and B to 9B, which is the softest. HB pencils are midway.

ENGLAND

Graphite sticks and powder

Thick graphite sticks are usually hexagonal, but can also be rounded, square or rectangular in section.

Made from graphite powder cooked with clay, like graphite pencils they range from **HB** to **9B**.

The length varies from 75–130mm (3–5in) and holders are available so that short lengths of stick can be used.

Pure graphite is sold in powder form in small jars or paper packets.

The colour ranges from silver grey to black grey.
It can be worked with the fingers or a torchon.

Torchons are made from rolled paper.

Coloured pencils

The pigment in the lead of coloured pencils is bound
with wax and the softness varies slightly. Any increase
in the wax content makes the lead harder. Sets of
pencils can contain as many as 120 colours but a
range of about 30 will give a basic collection. There
are discernable differences between manufacturers so
it is worth trying out a few to see which suits you best.

Coloured pencils are light
and can be sharpened to
a fine point for detailed
drawing.

Varying the pressure
will produce light to
dark tones and using
the tip or the side gives
different effects.

Water-soluble coloured pencils

This medium can be used in the same way as normal coloured pencils, but if you add water the colour dissolves and can be blended with a brush like watercolours. They are a unique cross-over between drawing and painting and they have the advantage of being easy to use, relatively cheap, and don't leave you with a mess to clean up.

There are two grades;
the softer pencils
give a good wash
while the harder ones
dissolve with a paler
wash, often with the
original drawing lines
still visible.

Charcoal sticks

Drawing charcoal is usually made from willow twigs but can also be made from beech, poplar and vine. Willow and beech produce a bluish-black line while vine charcoal is a brownish-black colour. Holders enable you to work cleanly and are available from 4–6mm (⅛–¼ in) in diameter.

The thickness of the sticks vary and they can look twiggy or be regularly shaped with angled or pointed tips.

The hardness varies, but with too much pressure all charcoal will break.

Charcoal pencils

The charcoal used in pencil form is harder than in sticks and is smooth to work with. The pencils contain natural or compressed charcoal that has been mixed with soot or oil and clay to give a dark, greasy colour that smudges easily.

Charcoal pencils can be sharpened to a point for fine detail.

They are available in three grades of tone: light, medium and dark.

Tinted charcoal pencils have been created in a range of over 20 shades, adding a hint of colour to this traditional drawing medium.

Conté sticks and pencils

Made from compressed chalk mixed with pigment, gum and grease, conté sticks are harder and oilier than pastels and break easily. The traditional colours are black, white and grey, plus the earth colours of sepia, sanguine and bistre. Today, a much wider range of colours is available and conté also comes in pencil form.

Traditional coloured conté sticks

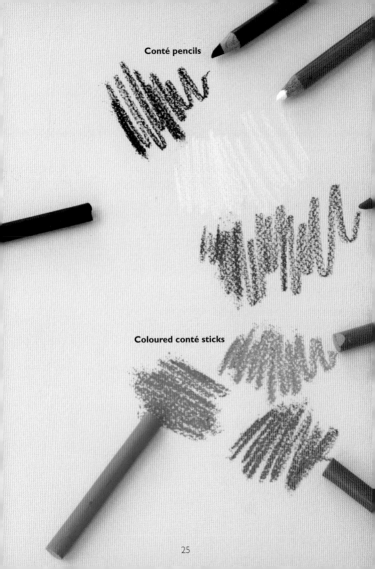

Conté pencils

Coloured conté sticks

Pastel pencils need fixing in the same way as regular pastels.

They are good for final details and for design work where colour is needed.

Pastel pencils

In a range of about 60 bright colours, these wood-cased pencils with a pastel lead are ideal for beginners as they are less crumbly than pastels and are easier to control.

Coloured chalks are made from powdered limestone rock mixed with pigments and a binding material.

Sharpen chalks on sandpaper.

Chalks

Round or square in section, chalks are traditionally made from natural materials — chalk or gypsum for white and carbon for black. A limited range of coloured chalks is also available.

Soft pastels

These vibrant sticks of colour are made from ground pigment bound with a little gum. They are round in section and available in different sizes. Within a single colour there may be several tint grades with the mid grade containing the purest colour.

Soft pastels are sold cased in paper or plastic.

Pastels crumble and break easily and should be stored separated, or at least in colour groups.

The finished drawing needs to be fixed.

They are smooth to work with but do not blend well, which is why there is a huge range of colours.

Hard pastels

Usually square in section, hard pastels contain less pigment and more binder than soft pastels, which makes them more stable and less messy to use.

Pastels are often sold in sets designed for a specific purpose, such as landscapes or portraits.

Hard pastels can be sharpened and are good for drawing crisp lines or for adding highlights and detail to a soft pastel drawing.

Crayons

This water-resistant drawing medium is available in a range of bright colours and is commonly used. Crayons often have a paper wrapping and feel sticky to draw with. Wax crayons are ideal for making rubbings.

Easy to work with, crayons are clean, blunt and non-toxic.

They cover the paper well and give a shiny finish.

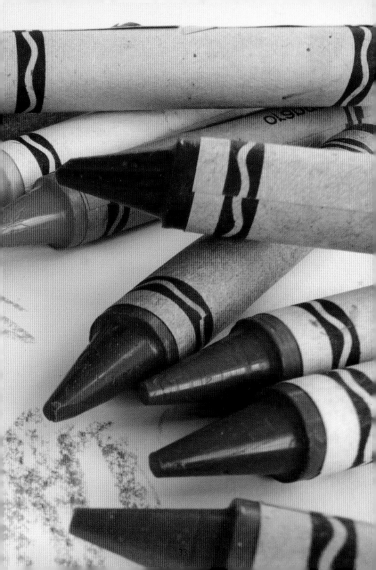

Ink pens

Dip pen holders are designed to take a range of nibs suitable for both drawing and calligraphy. The nibs are made from a variety of metals with rounded, fine, pointed, square or angled tips.

Dip pen with nibs

These are also called 'roundhand pens' and are mostly used for calligraphy.

Fountain pens have a range of nibs but the reservoir is unsuitable for waterproof inks.

Sketching pen with cartridge

Sketching pens are designed specifically for drawing; they, too, have a reservoir or use cartridges.

Mapping pen

Mapping pens use fine tubular nibs for delicate sketches.

Ink pens

Technical pens produce lines of a precise, regular thickness. The ink is controlled by a needle valve, which gives a continuous and consistent flow.

Indian ink artisit pen

The nibs are interchangeable and come in up to 15 sizes ranging from 1.0–0.10mm.

They can have a refillable reservoir for the ink or use pre-filled cartridges. Simply unscrew the nib to change it.

Bamboo pens are usually sold in three widths and are sometimes double ended giving two widths on one pen. They produce a strong bold line.

Quill opens are made from goose, turkey or swan feathers.

Bamboo pens

Reed pens have an obliquely cut nib that is soft and flexible and produces a bold irregular line.

Waterproof inks

Always use dip pens with waterproof inks, which can be full strength or diluted with distilled water. Nibs must be cleaned immediately after use. When dry, the ink does not dissolve under a wash, instead the lines remain crisp.

951 · BLACK INDIAN INK

They are transparent, waterproof, can be mixed or diluted and have a high colour brilliance.

Shellac-based pigmented inks come in a range of about 30 colours.

Shake well before use to distribute the pigment. The degree of light fastness varies with the manufacturer.

BRILLIANT GREEN

960 SUNSHINE YELLOW

Water-soluble inks

Liquid water-based coloured inks can be diluted with water and dry evenly without streaks. There is a wide range of transparent colours plus an opaque black and white for use with both pens and brushes.

They can be used on glass, wood and ceramic surfaces as well as paper and board.

They can be mixed, are water-resistant when dry and reasonably light fast.

Acrylic inks come in a range of around 30 colours with a pearlescent range of about 20 colours.

Ballpoint pens

This drawing medium is ideal for instant use and working fast, as the roller ball in the tip floats over the surface. The range of pens is huge and it is worth trying out several different makes to find one that suits your style of drawing.

The thickness of the line varies from very fine to medium.

Cheap pens may smudge and blots of ink can build up on the tip.

The basic range of colours usually includes black, blues of various shades, red and green.

Fibre-tip and marker pens

Felt pens with pointed or wedge-shaped tips come in a range of colours, which are either water or spirit based. Both have a tendency to fade with time. Spirit-based colour bleeds slightly giving a softer outline and the colour may go through the paper marking the layer underneath. There are papers available that prevent this. The line ranges from fine to thick but can lack variety and the tips wear down quickly.

Felt-tip pens

Gel pens

Marker pens

Refillable marker pens using a spirit-based
ink and with interchangeable fibre tips are
available. The inks can be mixed, dry fast
and do not smudge.

Brush pens

Most brush pens must be shaken before use and have a push-button mechanism that floods the brush with ink. Repeat the action as the colour fades and runs out. A brush pen with cartridge refills is also available.

A pen with interchangeable tips and brushes gives a choice of widths.

ish the button to charge
e brush with ink.

Over 100 spirit-based colours,
some with a metallic finish,
are produced.

Oil pastels

The pigment in oil pastel sticks is combined with oil instead of the gum used in normal pastels. This gives a translucent effect. The colours are strong and stick to the paper well. Oil pastels are easy to control and a holder enables very short pieces to be used cleanly.

Blend the colours on the
paper using white spirit
or turpentine and a
brush or piece of rag.

Oil paint sticks

Made from real oil paint moulded into sticks, the colour simply flows on to the support. A protective film prevents the stick from drying out and a paper sleeve supports it to prevent it from breaking. The film reappears when you stop using the stick for any time. A range of over 50 colours is available, including some that are iridescent.

They can be troublesome to blend although this can be achieved on the paper surface by smudging the oil with your fingers.

The sticks come in two
widths and two lengths.

The final effect
is not unlike that
left by unthinned
oil paint.

OILBA

Erasers

Natural rubber erasers are used for pencil, sanguine and chalk pastel drawings and are suitable for all types of paper. Use transparent plastic erasers for pencils, and to some extent coloured pencils, to remove smudges.

The classic India rubber is two sided, soft at one end for pencil and coloured pencils and hard at the other end for ink, Indian ink and toner.

A kneadable putty rubber is soft and easily shaped and has excellent erasing qualities. Use it to erase or lighten pastel, chalk and charcoal drawings. It is also suitable as a cleaning rubber.

Erasers cased in wood are ideal for the precise removal of marks. They often come with a rubber at each end, one hard and one soft and they are sharpened like a pencil.

Fixatives

Aerosol fixatives are based on synthetic resins. Spray according to the manufacturer's instructions and avoid over saturation. Use them to fix pastel, charcoal and coloured pencil drawings. Matt or gloss sprays give a strong protective coat with a different finish.

Fixative also comes in a bottle for use with a diffuser – two tubes and a mouthpiece. When you blow through the mouthpiece a fine spray is produced.

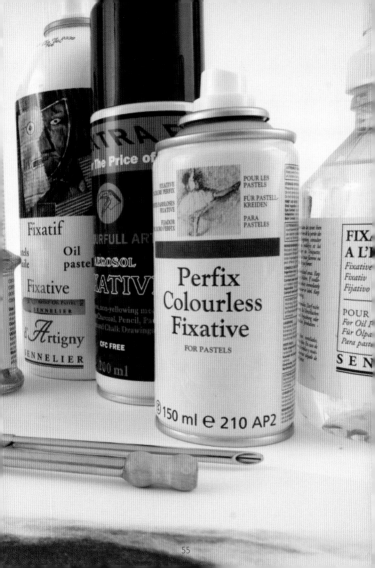

Brushes

Sable brushes are considered the best as they are supple, springy and hold a point, but they are expensive. Alternatives are ox hair, which is coarser and makes good flat brushes, and squirrel hair, which holds water well. Always wash your brushes immediately after use, especially when using inks.

Use riggers for fine lines.

Oriental brushes are designed to make characteristic fluid marks.

Round brush sizes range from No.0000 to 24, which is the largest.

Flat brushes are measured by width.

The way a brush is held will vary the mark it makes. Hold it vertically for fine lines and horizontally for thicker strokes.

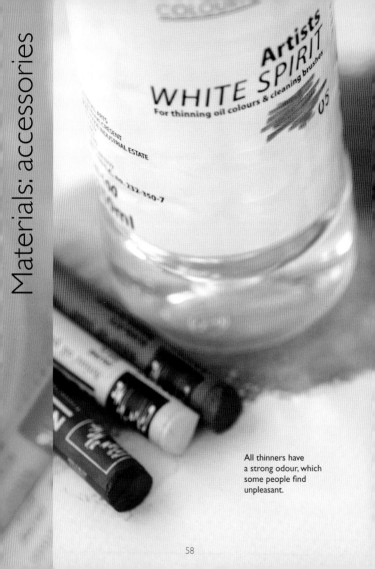

Artists
WHITE SPIRIT
For thinning oil colours & cleaning brushes
05

All thinners have
a strong odour, which
some people find
unpleasant.

Art suppliers
have produced
a low odour paint
thinner for use
with oils.

Sansodor
(Low Odour Solvent)

75 ml ℮

Thinners

To dilute oil media there
are four different thinners
available. Traditionally, artists
used turpentine but today
this is more likely to be a
turpentine substitute. White
spirit can also be used as a
thinner and to clean brushes.

Turpentine
FOR OIL COLOUR
75 ml ℮ 2.5 US fl. o

Boards, easels and light

The sizes of drawing boards are related to paper sizes. The best boards are designed not to warp when wet and are made of a close-grained wood to give a smooth surface. Home-made boards can be produced from blockboard, chipboard or MDF. Cover them with a sheet of cardboard to stop pencils digging in.

Full-size easels hold a drawing board between adjustable wedges and can be folded up easily for storage and transport. The legs are individually adjustable for height and to suit uneven ground.

When working indoors fit an adjustable lamp with a daylight-simulation bulb.

Table easels adjust to several angles with the board held by a retaining lip.

Storing soft pastels

If soft pastels are kept in a box they rub against each other and dirty pastels result in muddy colours. A strip of paper folded like a concertina and fitted into a box will keep pastels apart. Corrugated paper fitted in the same way is another option. As a last resort try keeping pastels of a similar colour together.

Several home-made options are possible.

You can purchase wooden pastel boxes which accommodate many types and brand of pastel.

Some manufacturers sell their pastels set in foam cutout sheets.

Cleaning soft pastels

However hard you try to keep pastels clean, colour
will transfer from your fingers from time to time.

Method one

Simply clean
your pastels
one by one by
rubbing them
in a piece of
kitchen towel.

They will
soon look
clean again.

Method two

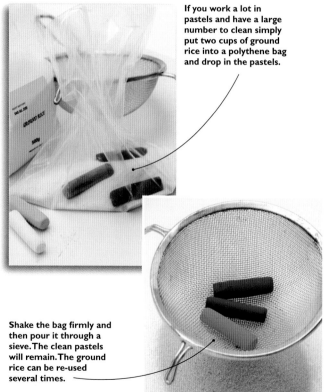

If you work a lot in pastels and have a large number to clean simply put two cups of ground rice into a polythene bag and drop in the pastels.

Shake the bag firmly and then pour it through a sieve. The clean pastels will remain. The ground rice can be re-used several times.

Stumps, shapers and blenders

Compressed or rolled paper stumps or torchons resemble a pencil and are available in two lengths and assorted thicknesses. Some have one point, others have a point at each end. Use them to blend and shade media such as graphite pencils and powder, charcoal and pastels. When they are dirty, simply tear off a layer of paper to reveal a clean surface.

Burnishers and blenders are pencils that are designed for use with coloured pencils to add shine and to blend colours on the paper.

Burnishing pencil

Colour shapers are made with a durable silicone-rubber tip on a handle. Use them to create surface effects by mixing, blending and smudging. The softer tips are ideal for pastels, charcoal and thin paints. Harder tips are more suited to thicker media.

Stumps

Shaper

Blending pencil

Knives and sharpeners

Pencil sharpeners for two sizes of pencil are quick and easy to use, but craft knives offer more control and can make a longer point than a conventional pencil sharpener.

Pencil sharpeners

Both knives and scalpels
come with replaceable
blades and sheaths to keep
the blades protected.

A scalpel is useful for
cutting paper and shaping
quill pen nibs, as well as
sharpening pencils.

Craft knife

Scalpel blade

Use craft knives and scalpels
in sgraffito to scratch into
coloured surfaces to reveal
a second colour beneath.

Extenders and holders

These handy accessories make working with crumbly and dusty media, such as pastels and charcoal, much cleaner. They are also vital if you want to use every scrap of every stick. They vary in design and in the diameter of the stick they can hold.

Pastel

Charcoal

Extenders also provide better balance and alleviate hand fatigue.

Intus a

If you use coloured pencils frequently and find yourself throwing away one-third of your investment, you could save a great deal with the aid of an extender.

Resists

A resist is laid down to reserve an area of the support preventing it from taking up subsequent layers of colour. Some can be removed, others remain permanently.

Masking fluid is painted on to the support using an old brush. Apply the paint and once it is dry, remove the masking fluid by rubbing it off with your finger.

Traditionally, masking fluid is a pale yellow colour but tinted fluid and colourless fluid, which turns white when it dries, are also available.

A wax candle or wax crayon will resist any paint or ink applied on top.

Art Masking Fluid

for Water Colour

75 ml ℮ 2.5 US fl oz

Clean all brushes in cold water immediately after using masking fluid.

Cartridge paper

A general-purpose sketching paper, cartridge paper
is available in sheets, rolls and pads of several weights.
The heavier papers have a slight surface texture.

The quality of paper
must, in part, reflect
the status of the work.

Cartridge paper is ideal for a sketch that you may want to display.

Cartridge paper with its smooth finish allows pens and pencils to glide over the paper.

Bristol board

If you are preparing to make a finished artwork, you may wish to use a Bristol board. This smooth firm white board is ideal for fine pen or pencil work.

Bristol board is heavily pressed and polished to give it a great finish for drawing.

Bristol board provides a stiff, strong surface to work on without the need for mounting.

Cotton trimmings
are blended to make it
more durable than paper
made from wood pulp.

**Bristol board provides two
working surfaces, front and back.**

Art board

Exceptionally strong, multi-purpose art board can be used for hundreds of art and craft projects. Sheets of board with one or both surfaces covered in a range of art papers are available, however they can be expensive.

Art board is the same colour on both sides.

Choose from lightweight, medium weight or heavy weight.

HP watercolour paper

HP stands for hot pressed. The watercolour paper is pressed between hot rollers and this gives it a smooth surface that is good for detailed pen and pencil drawings. If adding a wash, the paper should be stretched before use to prevent it from cockling.

Hot-pressed watercolour paper is milled through a set of heated cylinders to smooth the cotton fibres down, which causes the fibres to lay down in smooth arrangement.

**HP watercolour paper is the
smoothest texture available and
preferred by artists who use
lots of detail in their artwork.**

CP (NOT)
watercolour paper

Cold-pressed paper is passed through cold rollers and is often referred to as NOT paper because it is not hot pressed. It has a slight tooth that works well with a variety of drawing media, such as graphite pencils and watercolour pencils.

CP watercolour paper has a texture that is in between smooth and rough.

NOT paper is the most common and the most popular among watercolour artists.

After the moulds of paper are created, they are then milled through a set of cylinders to get the cotton fibres to lay down.

Rough
watercolour paper

The coarse texture of rough watercolour paper often gives a lively broken line, ideal for bold techniques.

Pastels drawn on rough paper will be least liable to fade.

Paint from very watery washes tends to collect in the indentations in the paper, creating a grainy effect.

Rough paper is generally not regarded as a good paper for painting fine detail, but is excellent for a loose, expressive style of painting.

If you sweep a dry brush lightly across the surface, you will apply paint only to part of the paper, the tops of the ridges, and not in the indentations.

Rough watercolour paper has the most textured surface, or most prominent tooth.

Pastel paper

Paper for pastels can be bought in single sheets or pads in a range of about 14 colours. The colour of the paper shows through the pastel line giving a warm or cool tonal value. The choice of colour to suit the subject matter is an important consideration. There are two specialized papers for pastels, Mi-Teintes pastel paper and Ingres paper.

Mi-Teintes pastel paper is ideal for pastel, chalk, sanguine and oil pastel, as well as pencils.

Ingres paper has a textured surface made up of fine parallel lines and it sometimes has a slight fleck. Use it for pastels, oil pastels and conté pencils.

Mi-Teintes pastel paper is thicker than Ingres paper with one side smooth and the other with a hexagonal textured pattern. It comes in a range of colours that are light resistant as they are coloured in the pulp.

Coloured paper

A range of matt surface, lightweight, 130gsm (80lb) papers is available in a selection of colours. A popular size is 50 × 70cm (20 × 27.5in).

Coloured paper has a characteristic subdued veining.

It is sold in rolls of 70cm x 3m (2 x 10ft) and is available in about 13 dark colours that have been dyed in bulk.

Sugar paper is a lightweight 70gsm (40lb) paper with one side smooth and the other rough.

Textured sandpaper

Fine sandpaper sheets hold pastel pigments
well, but they are not suitable for oil pastels.
They come in pads or sheets of various sizes
and colours.

Sandpaper adds both texture and
dimension when used with
various media.

Other papers

The best handmade papers are made from
cotton rags, one sheet at a time. The edges are
thin and uneven and there is often a right
and a wrong side, which can be identified by
checking the watermark. They are expensive
and are mainly used for watercolour painting.

Indian handmade papers and Khadi papers are also made from rags and the latter often incorporate flower petals and grasses.

Card and cardboard

These less conventional supports should not be overlooked. The weights and surfaces vary but they are ideal for working boldly with chalks, charcoal, graphite sticks and the many different kinds of pastels.

The bumpy surface of cardboard may not allow for a very smooth effect, but otherwise this is an ideal, readily available support for acrylic, oil and gouache, but not for watercolour.

Cardboard is a very inexpensive support that is relatively hard-wearing.

A spiral binding allows you to open the pad out flat and to remove sheets easily.

Sketchbooks and portfolios

Every art shop sells a range of sketchbooks, small pads and notebooks suitable for drawing. Offcuts of paper from your own collection could also be sewn together to make a useful sketchbook.

Bound books make a handy visual diary. By turning the page or drawing across the centre, a variety of page sizes can be obtained. The papers used vary from cartridge to fine watercolour paper.

A portfolio is ideal for storing unused sheets of drawing paper or sketches and paintings. They can accommodate various paper sizes.

Paper weights

Paper is sold according to weight, which is an indication of its thickness. The weight is measured in grams per square metre (gsm) or pounds (lb) per ream, which is 480 sheets. The surface texture varies and so does the size of the sheet. The lighter weight papers are also available in pads, glued on one or all four edges, or spiral bound books.

Weight	Surface	Available in
190gsm/90lb	HP, NOT, Rough	sheets, pads, spiral bound
300gsm/140lb	HP, NOT, Rough	sheets, pads, spiral bound
425gsm/200lb	HP, NOT, Rough	sheets
550gsm/260lb	HP, NOT, Rough	sheets
640gsm/300lb	HP, NOT, Rough	sheets

The quality of paper you choose will affect the finished result, particularly with wet media such as watercolour. Tough surfaces can be worked on to build up textures, rough surfaces hold pigments and add touches of the paper colour to the finished work. A smooth paper surface will not catch when using a pen.

Most art paper is made from cellulose, either wood or cotton. The best quality papers are 100 per cent cotton and are referred to as rag. They are expensive.

Paper can be machine-made, mould-made or handmade with the latter being the most expensive. Handmade and some mould-made papers have a rough edge, called the deckle edge. They may have a watermark and this shows which is the top surface.

Paper is sized by adding starch or gelatine to the pulp mix, called internal sizing, or to the surface. The amount of sizing affects how the paper absorbs water. The more sizing used the less absorbent the paper is.

TECHNIQUES

A visual directory of drawing techniques providing you with everything you need to explore and experiment with different techniques and mediums. Use it as a handy reference for when you want to know how to use a particular tool, or as a catalogue of inspiration when seeking new ideas to try.

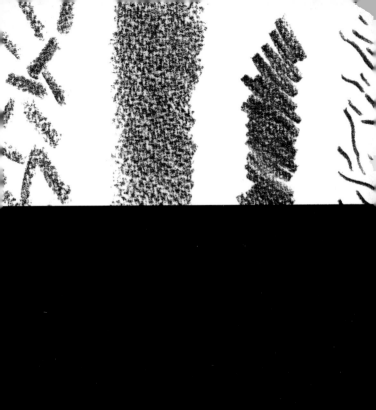
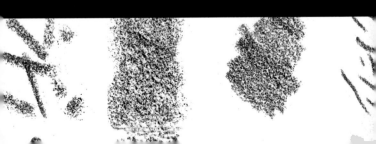

Graphite pencils

Choose a smooth drawing paper and HB, 2B and 4B
pencils to experiment with different techniques.

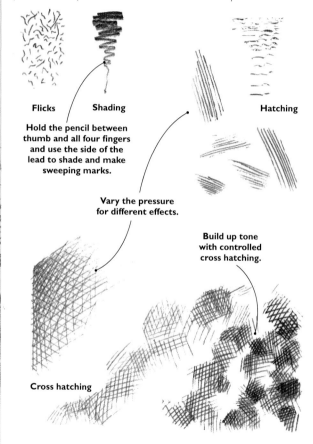

Flicks **Shading** **Hatching**

**Hold the pencil between
thumb and all four fingers
and use the side of the
lead to shade and make
sweeping marks.**

**Vary the pressure
for different effects.**

**Build up tone
with controlled
cross hatching.**

Cross hatching

Scribbles

Hold an HB pencil vertically or at a slight angle between thumb and forefinger to create crisp detailed drawings.

Build up texture and volume using scribbles, tiny flicks, stippling, hatching and cross hatching.

2H

HB

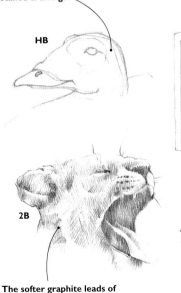

2B

B

The softer graphite leads of 2B or 4B pencils can be used to demonstrate expression.

Graphite pencils
Shading and blending

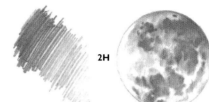

2H

After shading, the marks can be blended using a finger, torchon or shaper. Areas can be lifted out with a putty rubber.

HB

Both the way the pencil is held and the smoothness of the paper affect the look of the shading.

B

The softer the lead and the greater the pressure used, the darker the shading will be.

2B

Choose a 2B lead for an all-round drawing pencil. The lead blends well but does not smudge easily.

4B

Use a soft lead – 4B and upwards – for darker areas.

6B

Lighten areas using an eraser or a putty rubber, which can be shaped into a point for small areas.

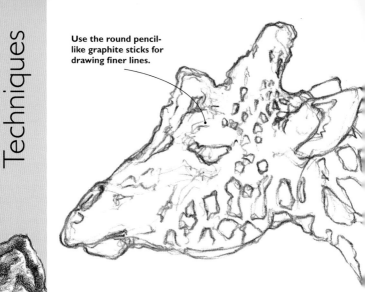

Use the round pencil-like graphite sticks for drawing finer lines.

Graphite sticks

Graphite sticks are soft, ranging from HB to 9B, and smudge easily, so whenever possible work from left to right (or right to left if you are left-handed) and try not to rest your hand on the support.

As you cannot produce as detailed a drawing with graphite sticks as you can with traditional graphite pencils, they encourage a looser drawing style and are ideal for large-scale work.

The soft quality of graphite sticks makes them easy to shade and blend using a finger, torchon or blender.

Choose the shorter chunky hexagonal sticks for bold, sweeping marks and shading.

Graphite sticks
Textures

Three different types of paper were used here, with four different graphite leads, to show how the paper surface can affect the texture of the marks.

Rough paper

Textured Sandpaper

Watercolour paper

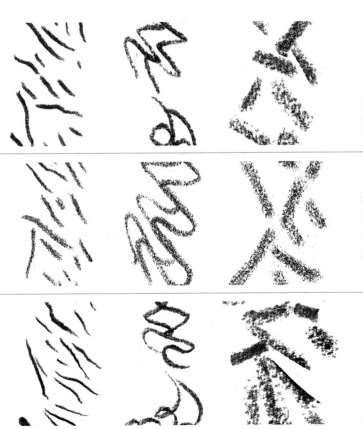

Graphite powder
Applying tone

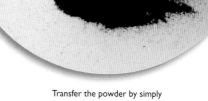

Transfer the powder by simply
tipping a little on to the surface
and then dip a finger into it.

To create areas of shading, simply rub the powder directly on to the support.

Alternatively, use a stiff bristled brush or a torchon, as well as your finger to create different effects with the density of the powder.

Graphite powders look particularly good on heavily textured papers.

They are useful for shading large areas of a drawing.

Graphite powder
Creating textures, erasing and fixing

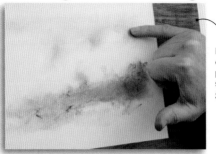

Interesting cloud effects are possible using a small amount of graphite powder.

Build up the darker areas slowly by gradually adding more powder.

Remove areas of shading using a plastic eraser or a putty rubber.

A putty rubber can be moulded into a point for erasing fine details. Highlights can also be introduced with white pastel or chalk.

The finished drawing will need to be fixed using a spray fixative.

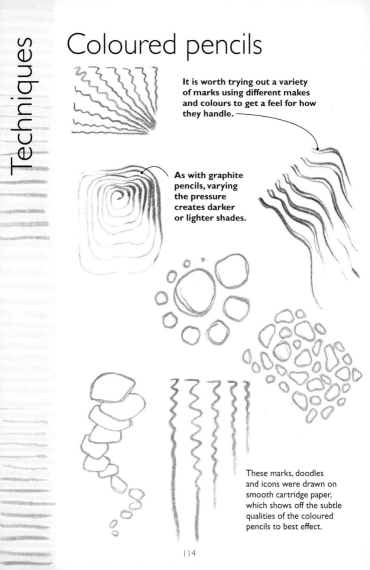

Coloured pencils

It is worth trying out a variety of marks using different makes and colours to get a feel for how they handle.

As with graphite pencils, varying the pressure creates darker or lighter shades.

These marks, doodles and icons were drawn on smooth cartridge paper, which shows off the subtle qualities of the coloured pencils to best effect.

Combine two or three colours for optical colour mixing.

To blend colours use a blender to combine the pigment under pressure.

Shading one colour over another creates a third.

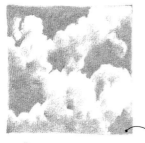

A worn tip or the side of the pencil softens the effect.

A sharp tip gives a crisp line for detailed drawing.

Coloured pencils
Building up shape

Coloured pencils do not smudge easily and are not easy to erase. They cannot be blended but building up layers of colour results in optical colour mixing.

Start by outlining and defining the shape with a pale colour.

Build up the shaping with dots of colour placed close together in the darker areas.

Less closely spaced dots of colour are used in the area of the highlights.

Use well-sharpened pencils for fine lines and detailed drawings.

On textured paper, the pencil dances over the surface leaving small areas of white that add sparkle to the drawing.

Use the side of the pencil lead for broad sweeps of colour and shading.

Shade lightly, overlaying several colours to build up the effect.

Cross hatching adds texture and shaping as well as shading.

A completely different effect is achieved when using toothed watercolour paper.

117

Coloured pencils
Burnishing

Burnishing is layers of coloured pencil overlaid with strong pressure so a smooth surface results. This image shows the contrast between the loose style of drawing with simple shading used for the motorbike, and the burnished area of the shiny fuel tank.

Burnishing with a plastic eraser blends the colour into the background.

Burnishing can be done with a paper torchon or a burnisher to add shine and seal the colour.

A light coloured pencil or a colourless pencil blender are alternative methods of burnishing.

To burnish small areas use a plastic stencil sheet to work through.

Lifting and sgraffito

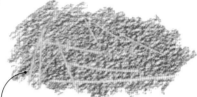

Scratching the surface to reveal the paper or colour below is called sgraffito.

Lift out colour using an eraser.

Use a strong support such as a NOT paper for sgraffito and lay the colour on thickly.

Water-soluble coloured pencils

Dry on dry paper. Use these pencils like ordinary coloured pencils or add water in a variety of ways to achieve very different effects.

Start drawing with a dry water-soluble pencil on a dry support.

Dip a second pencil in water to strengthen the depth of colour and get a slightly smudged effect. Take care not to get the wood too wet or it will warp.

Dry on wet paper

You can then wet the paper round the drawing using a large mop brush.

Drawing into the wet areas dissolves the pigment.

Dry then adding wet brush

The colour can be spread using a soft wet brush. Depending on the effect required, the pencil lines can be left visible or be given the appearance of a wash.

Wet point on dry paper

After the paper has dried, detail can be added. By dipping the pencil in water the depth of colour can be strengthened.

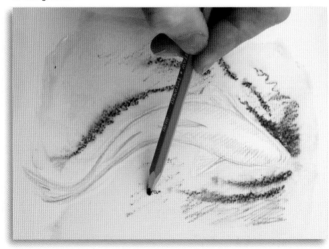

Water-soluble coloured pencils

Dry pencil.

Wash added.

In this drawing the colours were softened and blended using a wet brush after the drawing was complete. The original pencil lines are still visible.

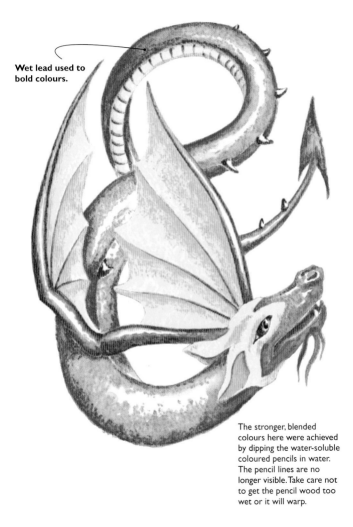

Wet lead used to bold colours.

The stronger, blended colours here were achieved by dipping the water-soluble coloured pencils in water. The pencil lines are no longer visible. Take care not to get the pencil wood too wet or it will warp.

Water-soluble coloured pencils
Blending with a brush

Lay down the pale colours first followed by the darker ones.

Blend them together with a wet brush.

Experiment with how much colour pigment to apply and how much water to use. Different brushes will also affect the results.

Allow the painted areas to dry completely before moving on to others, to prevent them bleeding into each other.

Applying by brush

Small areas of colour can be added by picking up pigment from the tip of the pencil with a wet brush.

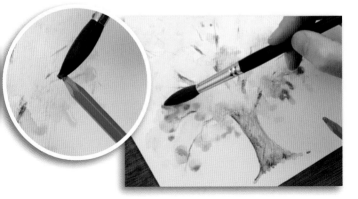

Water-soluble coloured pencils
Overlaying colours

Delicate effects can be created using the water-soluble properties with restraint.

Here, the detail of the flower centres and the foliage is maintained in the dry pencil drawing.

The petals of the flower have been blended using the fine point of a wet sable brush.

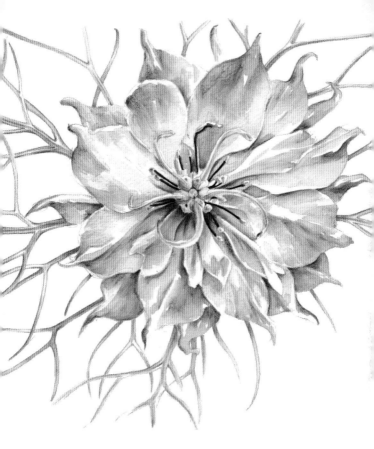

Turpentine or white spirit are alternative wetting agents to water. They dry fast and do not spread in the same way so are more easily controlled. Dipping the point of a paper torchon into these liquids will soften small areas of colour.

Charcoal sticks and pencils
Linear marks, tone, hatching and cross hatching

Charcoal pencils are more controllable than charcoal sticks and can produce fine lines. Thin sticks of willow charcoal can produce equally delicate drawings with practise.

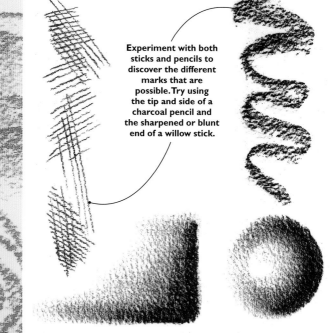

Experiment with both sticks and pencils to discover the different marks that are possible. Try using the tip and side of a charcoal pencil and the sharpened or blunt end of a willow stick.

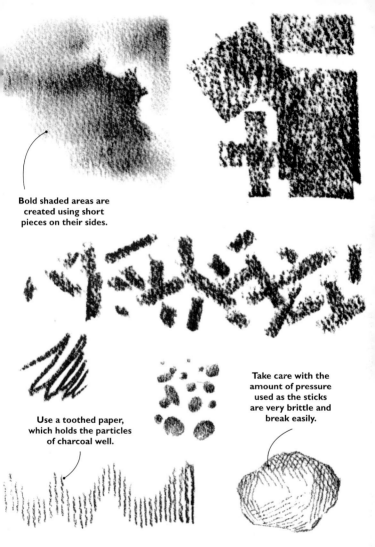

Bold shaded areas are created using short pieces on their sides.

Use a toothed paper, which holds the particles of charcoal well.

Take care with the amount of pressure used as the sticks are very brittle and break easily.

Charcoal sticks and pencils

Shading, blending and highlights

With experience charcoal can be used to create a variety of subtle effects. These drawings were done on smooth paper.

Soften round dark areas by blending the particles with a brush.

Try making broad sweeping marks using the side of the charcoal stick.

Reduce pressure as you move the stick to create dark to light shading.

Shade and blend the charcoal using a finger, stumps or a tissue.

Lift out areas using a putty rubber or a piece of bread to create highlights.

Build up an intense black with several layers of charcoal.

Charcoal is also soluble in water, which can be used to create a range of tones.

Charcoal sticks and pencils
Effects on smooth or textured paper

This sketch was drawn over four different types of paper, starting on the smoothest cartridge drawing paper and then over three watercolour papers with slightly different surface patterns. This shows how the choice of paper alters the effect of the charcoal.

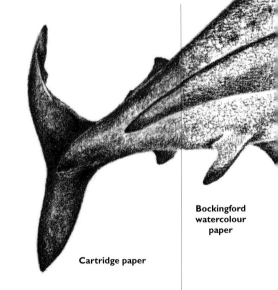

Cartridge paper

Bockingford watercolour paper

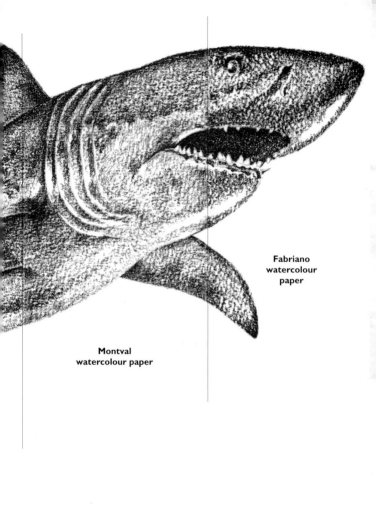

**Fabriano
watercolour
paper**

**Montval
watercolour paper**

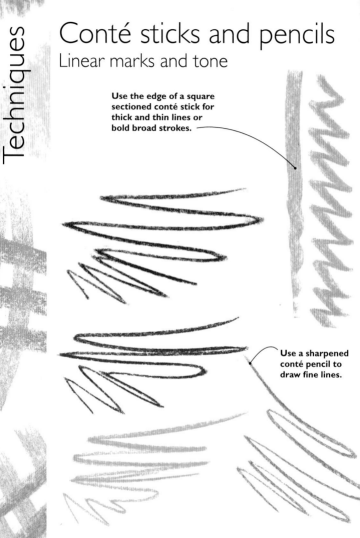

Conté sticks and pencils
Linear marks and tone

Use the edge of a square
sectioned conté stick for
thick and thin lines or
bold broad strokes.

Use a sharpened
conté pencil to
draw fine lines.

Techniques

134

Use the stick on its
side to create bands
of colour.

Make thick lines using
squared-off ends. The colour
adheres to the paper so
they do not smudge, but
they are difficult to erase.

Conté sticks do
not mix but blend
optically when one
colour is layered
over another.

Conté sticks and pencils
Using coloured supports

The brighter and lighter colours are best used on tinted papers with a rough texture. The support used here is a sandpaper type suitable for pastels. The depth of colour depends on the pressure used.

Conté sticks are harder than pastels and contain a greater pigment density.

Conté sticks can also
be used on prepared
primed canvasses for
underdrawing for a
painting.

Conté sticks
Textures

Using textured papers such as pastel paper, Mi-Teintes or a rough watercolour paper, as shown here, breaks up the colour and introduces flecks of white or whatever the background tint is.

Conté sticks are square in profile.

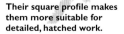

Their square profile makes them more suitable for detailed, hatched work.

They are used for
drawing, generally on a
rough paper that holds
pigment grains well.

Pastel pencils and chalks
Linear marks and tones

Pastel pencils are used for drawing or to add detail to a pastel painting.

They are perfect for preliminary sketching and for adding hatching, fine lines, shading and detail to a finished drawing.

Their hardness is midway between soft and hard pastels.

Chalks are best used on toned paper.

A slight tooth to the paper helps the chalk particles adhere to the surface.

Pastel pencils and chalks

The preliminary drawing of this elephant was done with a brown pastel pencil on rough paper. The colour was added using chalks. The pale areas of colour in the background were created using chalk and blended with a finger. The final details such as the eye, folds of skin and trunk were added using pastel pencils in different colours.

Pastel pencils provide a practical alternative to soft pastels.

Pastel pencils can be sharpened like an ordinary pencil and are used in much the same way so they will give precise, firm lines. They can be freely used with conventional soft and hard pastels.

Rough paper is excellent for a loose, expressive style of drawing.

You can use chalk
for an outstanding
sweeping effect.

Soft pastels
Linear marks and tones

These crumbly sticks are almost pure pigment. Draw using the end for a soft, expressive line.

Crumbled up, the colour particles can be worked with a finger or shaper.

The harder you press, the thicker the mark will be.

Use the edge of a broken end for fine lines and break them into short lengths for shading using the sides. Try drawing loosely with your whole arm, not just from the wrist.

The marks shown here were made on a sheet of tinted fine pastel sandpaper.

Soft pastels

Fine sandpaper and velour paper are very different to traditional pastel papers. Try them out using a series of marks to see how firmly they hold the pigment. It is not easy to blend colours on these papers and they use up pastels quite quickly.

Hold a pastel stick flat on the support and drag it lengthways down the paper to produce a line or parallel lines.

Vary the thickness of the lines and the pressure used when hatching to obtain variations.

Hatch in two or more colours to give an impression of continuous colour.

This cloudscape was created on pastel sandpaper. The final effect resembles an oil painting.

Soft pastels

Cross hatching can be done using a single colour or two or more colours. This is a useful way of building up tone or to block in a drawing quickly.

Feathering, a variation on hatching, is achieved using shorter strokes following the shape of an object.

Follow the contours of an object using curved hatching lines.

By varying the direction of the cross hatching a sense of form and shape can be created.

Lift the stick at the end of a stroke for a lively impression.

These pebbles were drawn using the sides of the pastels and then blended with a finger.

Soft pastels
Blending on sandpaper, textured paper and cardboard

Create variations in colour and tone by blending with fingers, torchons, rags, cotton buds or a putty rubber. Try spreading the colours using a brush dipped in water to create a wash or to soften lines. Scrape a pastel stick over an area of colour and press the dust into the surface for a stippled effect.

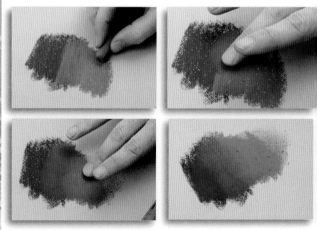

Experiment by trying out other supports such as a smooth cardboard sheet.

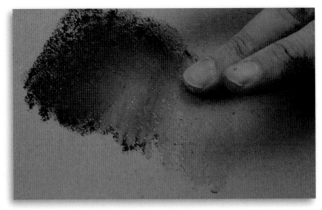

Pastel paper has a characteristic fine-line texture.

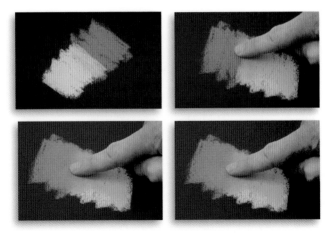

Good coverage is achieved on fine sandpaper but it uses up pastels fast.

Soft pastels
Scumbling

The bright colours of pastels lend themselves to the technique of scumbling. Using the side of the pastel, lightly drag it over the first layer of colour. The broken effect is very textural.

Black pastel with a colour scumbled on top adds depth.

Light colour over dark gives a shimmer effect.

A lighter colour over dark is most effective and the second layer can be worked in parallel stripes or shaded in several directions.

Close toned colours mix optically.

A downward stroke with the side of a pastel stick is used, and as the stick is lifted it creates a broken edge, reminiscent of individual leaves.

A darker green indicates shadow areas.

Hard pastels

Basic mark making

The binder content is considerably higher in hard pastels, which makes them easy to sharpen and less likely to break. This quality makes them more suitable for linear work as the variety of marks here shows. The sides can be used to block in large areas of colour, which can then be worked over, as shown opposite.

Hard pastels have more binder and less pigment yet this doesn't necessarily make them inferior.

They are also good for underpainting or outlining prior to overlaying with soft pastels.

Hard pastels come in a wide range of colours – both pale and extremely vivid

Hard pastels
Hatching and cross hatching

Vary the pressure to create lights and darks.

Wavy parallel lines add texture.

Hatching in two or more shades builds up colour using the linear quality of the pastels.

The range of colours of hard pastels is limited and they do not blend easily.

Use a tinted support and select
one to complement the subject.
A neutral beige sheet was chosen
for this stonewashed barn.

As a general rule, work
from dark to light.

Make your own tinted paper
with a watercolour wash but
stretch the paper to avoid
buckling.

Hard pastels
Scumbling and sgraffito

Experiment to create different effects such as scratching out and scumbling, where a pastel is dragged over an area of colour, or try light pastels worked over dark and vice versa.

The technique of sgraffito involves the use of a craft knife or scalpel to scratch into the surface colour to reveal a second colour underneath.

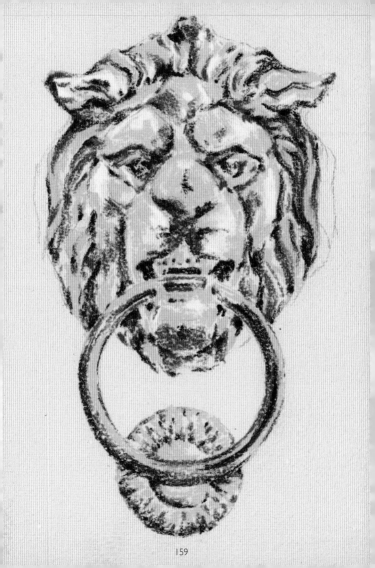

Crayons

Most crayon sets have a limited colour range and they do
not blend easily. An optical colour mixing effect is created
using hatching and cross hatching. Frottage, where crayon is
rubbed over a textured surface placed under the support,
gives interesting results. Wax crayons are useful as a resist
when using wet media such as watercolour pencils.

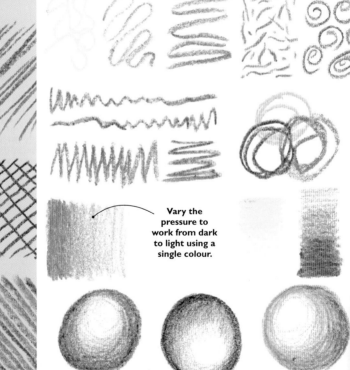

**Vary the
pressure to
work from dark
to light using a
single colour.**

Crayons
Blending, shading and sgraffito

When layered, some colour blending can be achieved and varying the amount of pressure gives a range of shades from light to dark.

Some colour mixing occurs when one colour is used over another.

Use a scalpel blade, craft knife, sharp nail or needle to scratch through the top layer of crayon.

163

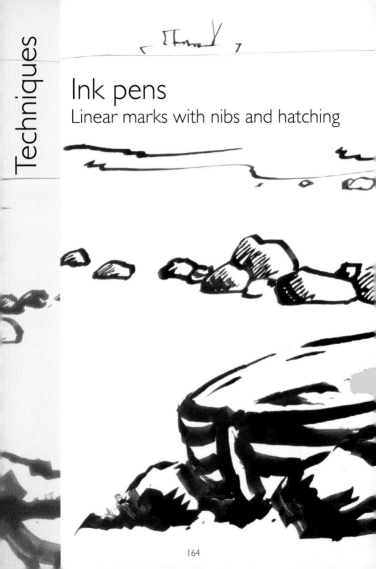

Ink pens
Linear marks with nibs and hatching

No 5½ fine nib for fine lines in the distance.

No 5 medium nib.

No 2½ thick nib for objects in the foreground.

L15 extra thick nib fitted with a reservoir for bold chunky lines requiring more ink.

Ink pens
Waterproof inks

For detailed drawings, a sketching pen, mapping pen or dip pen with a nib size 5 or 6, is ideal. Use a smooth paper surface so that the pen can move quickly and easily over it. Illustration board, Bristol board or HP watercolour papers are ideal. If the paper is sized internally or on the surface (see page 99), the ink line will not spread and colours will appear bright.

Work confidently and quickly when sketching in pen and ink.

Doodle to get to know how much ink your nibs hold. You cannot re-charge your pen when creating a flowing unbroken line.

A dip pen and waterproof ink were used in a loose sketchy style to draw this guitar.

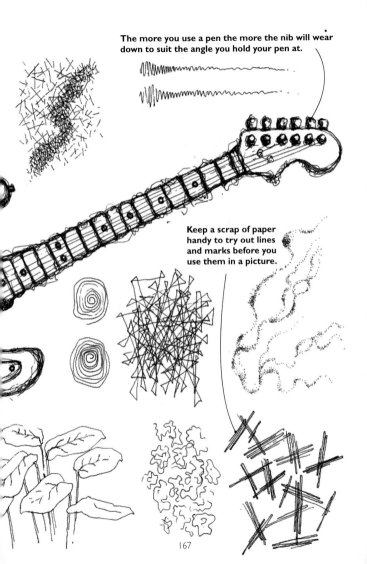

The more you use a pen the more the nib will wear down to suit the angle you hold your pen at.

Keep a scrap of paper handy to try out lines and marks before you use them in a picture.

Ink pens
Water-soluble inks

Water-soluble inks are available in many colours. They are fast drying and transparent, which allows them to be overlaid for optical colour mixing.

After the ink has dried it can be dissolved by wetting a brush with distilled water and dragging it over the lines.

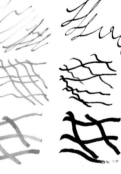

Use the flexible nibs of dip pens to create lines of different widths simply by increasing the pressure.

Dip pens with interchangeable nibs offer a range of widths. Sizes 0, 1, 1½, 2, 2½, 3, 3½, 4, 5 and 6, the finest, are sold as sets or individually.

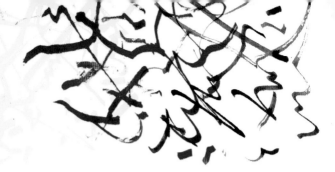

Water-soluble inks can also be used to paint with.

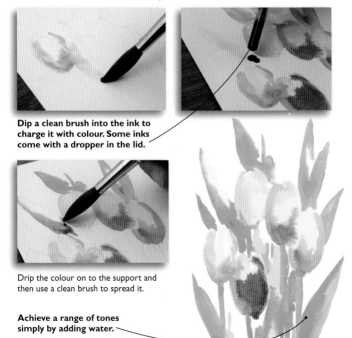

Dip a clean brush into the ink to charge it with colour. Some inks come with a dropper in the lid.

Drip the colour on to the support and then use a clean brush to spread it.

Achieve a range of tones simply by adding water.

Ink pens
Acrylic ink, drawing and marks

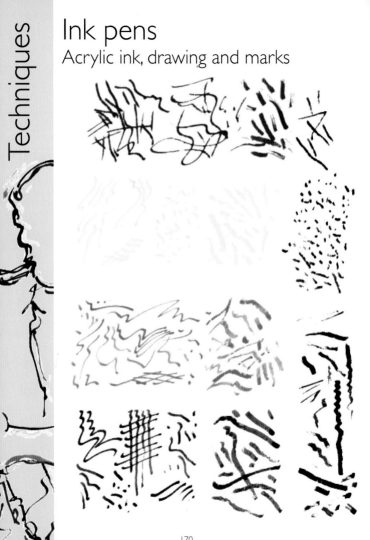

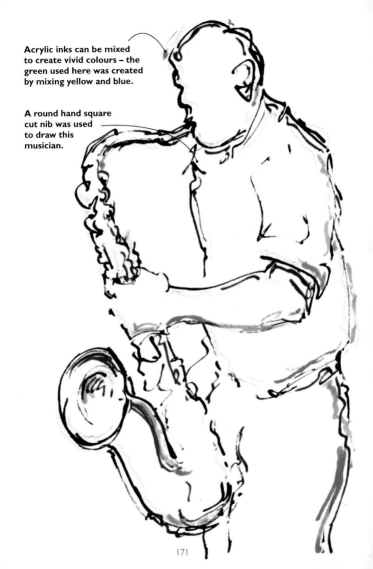

Acrylic inks can be mixed to create vivid colours – the green used here was created by mixing yellow and blue.

A round hand square cut nib was used to draw this musician.

Ink pens
Cutting a quill pen

Traditionally goose feathers are cut to make quill pens but swan and turkey feathers can also be used.

Goose feathers should be cured for a year before the nibs are cut. Trim the length to about 25cm (10in) and strip the barbs leaving about 2–3cm (1–1½in) at the end.

Use a scalpel with a sharp blade to cut the nib end off square and then make a 25-degree angle cut approximately 1cm (½in) long.

Cut a channel down the centre of the nib very carefully to avoid splitting the shaft. For a finer nib, trim the sides until you have the width of nib you require.

Experiment with the marks you can make, trimming the width of the nib if necessary. The quill should be washed in warm soapy water after use. As the nib wears down it can be re-cut.

Ballpoint pens

The fine line of a ballpoint pen can look mechanical, but tones and textures can be created using hatching, cross hatching or scribbles, where randomly created marks are built up to create depth.

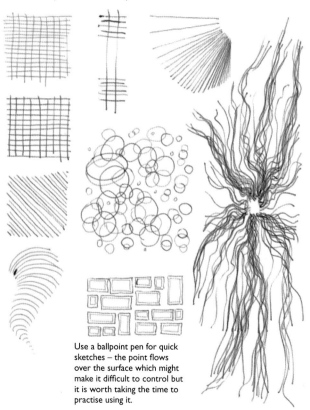

Use a ballpoint pen for quick sketches – the point flows over the surface which might make it difficult to control but it is worth taking the time to practise using it.

175

Ballpoint pens

The texture and shadows
in the sketch of cliffs
and the detail of a rocky
outcrop are built up using
a combination of simple
parallel lines, hatching
and cross hatching.

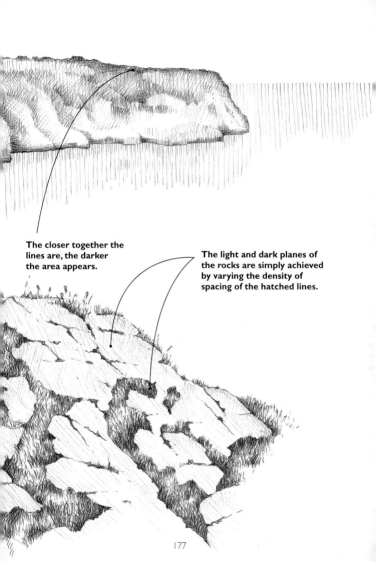

The closer together the
lines are, the darker
the area appears.

The light and dark planes of
the rocks are simply achieved
by varying the density of
spacing of the hatched lines.

177

Fibre-tips and marker pens

For quick sketches in bold bright colours, marker pens produce flowing lines. Use a paper that prevents the colour from bleeding or marking the sheet underneath.

Fine round-tipped marker pens produce sharp flowing lines.

Use marker pens for stippling, scribbling and rapid and cross hatching to create texture.

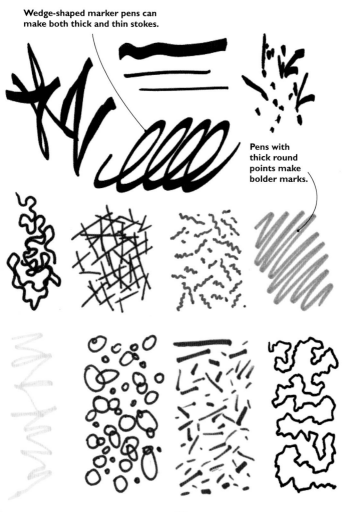

Wedge-shaped marker pens can make both thick and thin stokes.

Pens with thick round points make bolder marks.

179

Fibre-tips and marker pens

The colours are transparent and colour mixing is possible when they are layered.

You can achieve optical colour mixing by hatching one colour over another.

To avoid blobs, work fast using short strokes rather than long detailed lines.

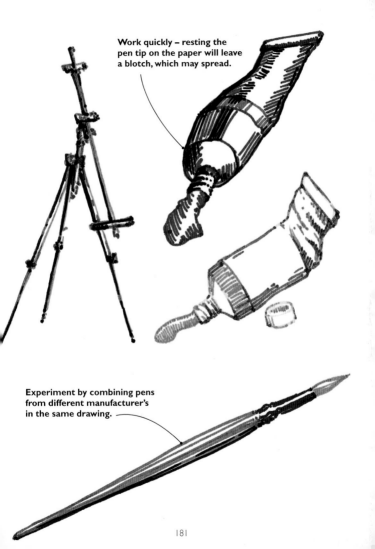

Work quickly – resting the pen tip on the paper will leave a blotch, which may spread.

Experiment by combining pens from different manufacturer's in the same drawing.

Brush pens
Linear marks in one and two colours

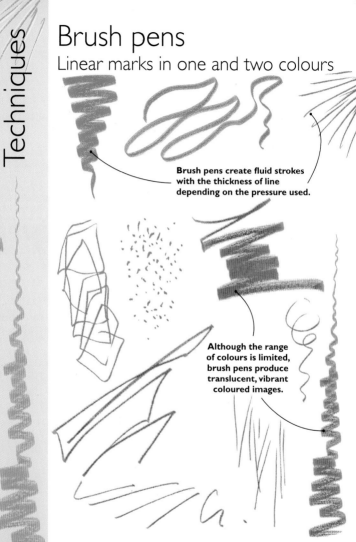

Brush pens create fluid strokes with the thickness of line depending on the pressure used.

Although the range of colours is limited, brush pens produce translucent, vibrant coloured images.

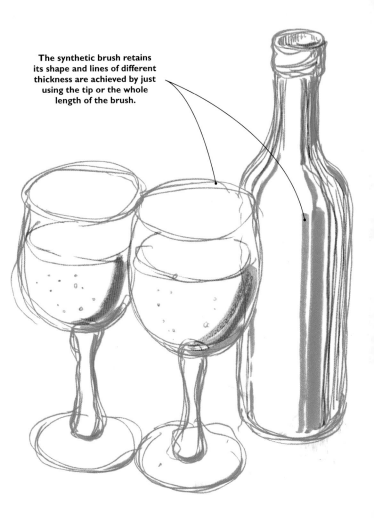

The synthetic brush retains
its shape and lines of different
thickness are achieved by just
using the tip or the whole
length of the brush.

Brush pens
Cross hatching, drawing and marks

The pump- or valve-activated ink comes in a dozen bright colours and several metallic shades.

Colours can be glazed over each other.

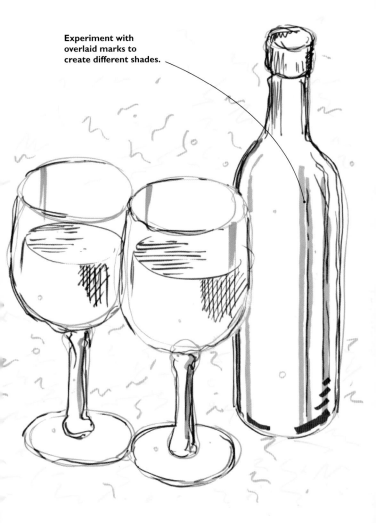

Experiment with overlaid marks to create different shades.

Oil pastels

These vivid colours are ideal
for bold bright drawings. They
are not as crumbly as soft
or hard pastels and you can
work on almost any support
from paper to card.

**Oil pastels cover the
support well with a
rich creamy finish.**

**Mix colours on the support by laying down
the first colour and then blending in the
second. Clean the pastel after blending.**

For fine lines sharpen the pastel with a craft knife.

Any underdrawing should be done using oil pastel or diluted Indian ink. Graphite pencil can smudge the colour.

Oil pastels
Tone and scumbling

Varying the pressure creates different shades and tones.

Light opaque colours laid over dark mixes the colours optically rather than blending them. It can give a shimmery effect.

The pastels can be laid one over the other without blending in a technique which is called scumbling.

A coloured sandpaper surface was used here with the colours worked over each other and lightly blended with a finger for a loose, sketchy effect.

Techniques

Oil pastels
Blending

Mix colours directly on the support, building up a
rich layer of colour and blend them using a finger or
a rag or brush dipped into white spirit or turpentine.
Building up the colour in this way gives an effect
similar to oil paints.

A background support similar
in colour to the subject was
used for this drawing of
chocolates. Test the pastels on
a scrap of paper before using a
coloured support so that you
can check the effect.

Try using a hog's hair
brush dipped in turps to
pick up paint from an oil
pastel stick to stipple on
the surface. Alternatively
dip the stick itself into
turps before using it to
blend with other colours
in the drawing.

Quick sketches, using a limited range of colours on a coloured ground are ideal for this medium.

Store oil pastel drawings interleaved with sheets of paper and keep them away from heat sources or direct sunlight, which can melt the colours.

Oil pastels
Layering

Oil pastels can be combined with other media, apart from pastels. They do not need fixing. The oil content makes them useful as a resist, and building up layers creates a bold, vibrant image.

The cup and saucer were drawn with bold strokes in vivid colours.

There is no blending, instead the individual drawn marks are clearly seen.

Oil paint sticks

Marks for texture

These thick, soft sticks can create the effect of an oil painting. Use them on a variety of surfaces including paper, canvas, cloth, glass or even ceramic.

Just three primary colours were used to create these rich mixes.

Apply oil paint sticks in thin layers. The drying time of several hours means that the paint remains workable, though some colours, such as blue and green, dry quicker than red and yellow.

Oil paint sticks

Quick sketching

Use oil paint sticks to create quick, spontaneous sketches and bold painterly effects; they are not suitable for fine-line sketching or detailed drawing.

Blue and red are blended with a finger to create the rich purple of the cherries.

The support is a canvas textured paper, which reinforces the look of an oil painting.

White highlights are added here and there.

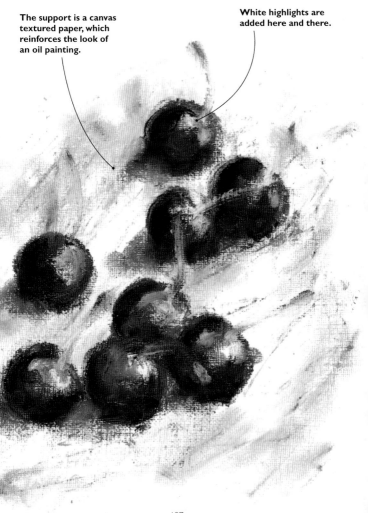

Oil paint sticks
Impasto

The paint can be built up to impasto thickness and worked with a palette knife. The thicker the paint the longer it will take to dry. Other factors affecting the drying time include temperature and humidity. The image should be fully dry within three days and can be varnished after six months.

Paint is laid on an area of the surface very thickly, usually thick enough for the brush or painting-knife strokes to be visible.

Oil paint is most suitable to the impasto painting technique, due to its thickness and slow drying time.

Acrylic paint can also be impastoed.

Impasto can add expressiveness to the painting.

Impasto makes the light reflect in a particular way, giving you additional control over the play of light on the painting.

Oil paint sticks
Sgraffito

A thick layer of colour is ideal for scratching out or sgraffito. Washes of colour can also be created using turpentine or white spirit spread over the oil paint with a rag or brush.

The background was created by smudging yellow, blue and red oil paint sticks all over the canvas-effect support.

The detailed drawing of tables and chairs were scratched out using a sharp stick.

COMBINING AND MIXING MEDIA

Explore the creative possibilities beyond one medium, and be encouraged to look at your work and style it in a new light. Use this section as an aid to expression and skill development and to look at the myriad possibilities of mixed media, which have all been selected because of their compatibility.

Graphite, coloured and watercolour pencils

Graphite pencils are commonly used for the initial sketch, which is then worked up in another medium. Take care when using them with coloured or watercolour pencils as the graphite lines can show through. Minimize this by erasing the lines gently to lighten the drawing.

The shadows were
created with soft
shading using a 4B
graphite pencil.

The initial drawing was done
on Bockingford watercolour
paper using coloured pencils
and watercolour pencils
softened into a wash.

Graphite pencils, soft pastels and charcoal

This cityscape shows the range of tones that can be achieved using HB to 6B graphite pencils and charcoal and soft pastels. Working from light to dark gives the picture a sense of depth.

Both pastels and charcoal need fixing.

Use the harder grades of pencil for the lighter background and the softer grades for the dark foreground.

Take care not to rest your hand on the paper to avoid smudges.

A smooth drawing paper was used for both drawings.

Build up the density gradually working up to the foreground silhouettes.

To prevent charcoal dust from muddying the pastel colours, fix the charcoal drawing before adding the pastels.

Use charcoal over pastel to tone down bright colours.

When a combination of charcoal and soft pastel is used, the coverage is less uniform.

The texture of charcoal and soft pastel are similar and they blend together well.

Graphite sticks, coloured and water-soluble pencils

This owl was drawn
using soft 4B and
8B graphite sticks
on a smooth
drawing paper.

**The softer
the stick
the darker
the line is.**

**Add a wash
of subtle
colour to
the graphite
drawing using
water-soluble
coloured
pencils.**

**Use coloured
pencils to add
highlights of
colour to the
beak and eyes
when the work
is dry.**

Graphite sticks, conté and soft pastels

Graphite sticks are the ideal choice for quick sketches to capture a pose.

Soft 4B and 8B sticks were used on a smooth drawing paper.

With conté pencils, hatching and cross hatching work better than shading.

Use soft pastels to add areas of colour to the sketch and conté pencils for more detailed touches.

Graphite sticks and hard pastels

These sunflowers were drawn using hard pastels on a sand-based pastel paper. An 8B graphite stick adds depth to the shadows in the centre of the flowers.

Combining and mixing media

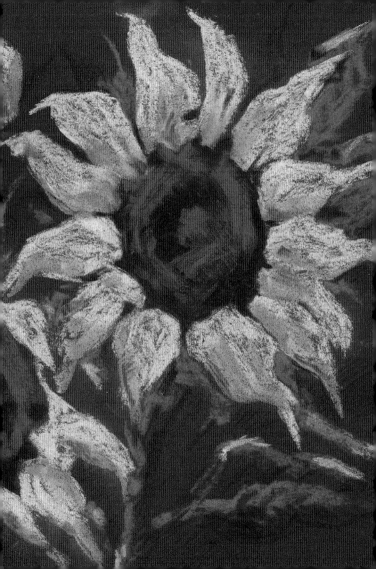

Graphite powder, conté and soft pastels

A variety of media was used to produce the image of the racing car. Graphite powder is ideal for large scale drawing, as well producing light and shadow on paper, while conté pencils and soft pastels produced the outline of the image as base to start.

The racing car's initial outline was sketched in with a conté pencil and developed with soft pastels.

A sprinkling of graphite powder round the wheels and in the background, blended with a finger, blurs the wheels and adds a sense of speed.

The finished drawing will need fixing.

Coloured pencils, soft pastels and charcoal

The contrasts in this drawing were created using three very different media.

The drawn elements of buildings, boats and vegetation were done using a combination of coloured pencils and charcoal.

The bright blue of the water and sky were added in soft pastel, which is ideal for covering large areas.

Combining and mixing media

Use hard pastel to add areas of intense colour, such as these berries.

The initial crisp outlines were drawn using a ballpoint pen on cream coloured Bockingford watercolour paper.

Use a dark-toned coloured pencil for drawing outlines rather than black and match the colour to the subject whenever possible.

The coloured pencil shading on the holly leaves captures their shiny nature.

Hard pastels and coloured pencils are ideal for controlled drawings.

Watercolour pencils, soft pastels and charcoal penci

Use a medium charcoal pencil to draw the outlines.

When dry, the final details can be added using coloured pencils and a charcoal pencil.

To achieve a painterly effect, blend areas shaded with water-soluble pencils and soft pastels with a soft brush dipped in water.

Watercolour pencils and soft pastels can be blended using water and a soft brush. The NOT watercolour paper has a textured surface, which is ideal for this technique.

The outlines were drawn
in waterproof ink, then
shaded colours were
added and softened with
a brush dipped in water.

When dry, waterproof ink will not
run or smudge, so it is ideal for use
with watercolour pencils.

Watercolour pencils, waterproof ink, ballpoint and fibre-tip pens

The waterproof ink lines remain crisp under a wash.

Add darker details using a ballpoint or fibre-tip pen once the wash has dried.

Charcoal sticks and pencils, graphite sticks and coloured pencils

Use a graphite stick to draw the outlines lightly.

Use coloured pencils to add touches of colour.

Strong shading can be added using charcoal sticks and pencils.

Charcoal sticks and pencils, conté and soft pastels

Soft pastel and charcoal will need fixing.

Blend the soft pastel using a finger.

The charcoal stick used to draw the outlines gives bold vigorous lines.

Charcoal sticks and pencils, waterproof ink and ballpoint pen

Combining and mixing media

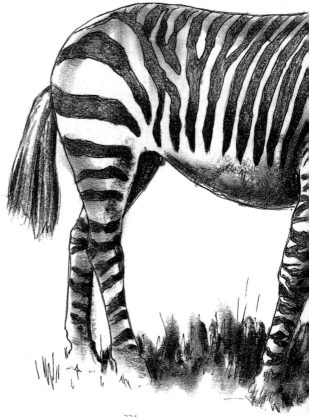

The outline sketch was drawn with a fine ballpoint pen, then worked up using charcoal sticks and charcoal pencils.

Strong charcoal blacks are built up in layers – too much pressure will break the stick.

The shadows on the animal and the grass were blended using a finger. A dip pen with waterproof ink added the final details.

Conté, graphite and coloured pencils

The delicate detailed drawing of this exotic scene was sketched in graphite pencil on smooth drawing paper.

A graphite pencil lightly sketched in the outlines of the drawing.

As well as earth shades, conté sticks and pencils are available in a range of colours that combine well with coloured pencils.

Use graphite pencils ranging from hard to soft to shade in the distant mountains.

A combination of coloured pencils and conté sticks blended together produces vibrantly coloured foliage.

Conté, waterproof ink and ballpoint pen

The initial sketch was
confidently executed
using a ballpoint pen.
Brightly coloured conté
sticks fill in the outline.

The corners of a conté stick produce fine, controlled lines. The sticks can also be sharpened with a craft knife.

Use the squared ends of the conté stick to produce wide sweeping strokes of colour.

The shaded areas were hatched in using a dip pen and waterproof ink.

Pastel pencils, conté and hard pastels

Both conté sticks and hard pastels add touches of colour to the ice cream.

The texture of pastels is ideal for conveying the softness of the ice cream.

The sketch was done in pastel pencil which is easy to control.

Use the sides of pastel sticks to produce larger areas of colour.

Both these images were worked on tinted Bockingford watercolour paper.

Pastel pencils, waterproof ink and ballpoint pen

Tiny flicks of colour using coloured inks add sparkle to the background.

Adding an outline and hatching using coloured waterproof ink and ballpoint pen makes the knickerbocker glory a crisper image than the ice cream.

Pastel pencils allow for more precise application of colour, giving the glass a hard look.

Soft pastels, graphite and watercolour pencils

A graphite pencil was used to draw the outline before colouring the pansies with pastels and watercolour pencils.

Wash over the colours with a damp brush to blend them.

Soft pastels, charcoal and hard pastels

Charcoal can be added to a pastel drawing, working on top of the colours. Both charcoal and pastels need fixing when the drawing is complete.

A drier, sketchier feel is created using pastels with charcoal.

Both these drawings of pansies were created on smooth white drawing paper.

Charcoal can dirty the clear colours of pastels. If used first, fix it before adding the pastel colours.

Soft pastels, ballpoint and fibre-tip pens

The outline was drawn with a ballpoint and fine fibre-tip pens.

Blend soft pastels with a finger for the overall colour before adding and blending the darker colours, used for the contours and shading.

Final shading and details are added over the pastels.

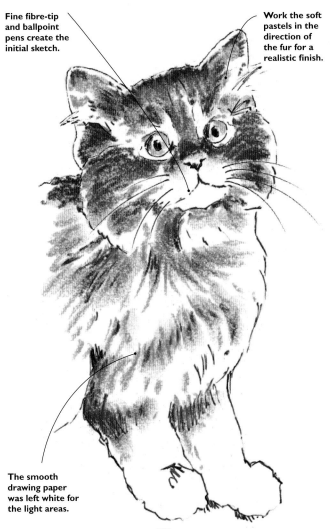

Fine fibre-tip and ballpoint pens create the initial sketch.

Work the soft pastels in the direction of the fur for a realistic finish.

The smooth drawing paper was left white for the light areas.

Hard pastels, graphite and coloured pencils

A combination of hard pastels and coloured pencils were used to create the sky effects below. The foreground was shaded using a soft graphite pencil. The result is a soft dreamy evening sky.

Hard and soft pastels and charcoal

When soft pastels are used instead of coloured pencils, the colours are strengthened. Adding charcoal deepens the colour of the clouds and the charcoal foreground is more of a silhouette. This sunset is much more dramatic.

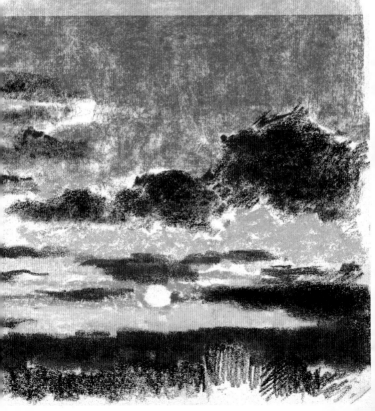

Hard pastels, acrylic and waterproof inks

The linear quality of hard pastels works well with inks, ballpoint pens and felt-tip pens.

A smooth drawing paper was used as a support for these sketches.

Dip pens with waterproof or coloured acrylic inks have a flowing calligraphic quality that creates expressive drawings.

Hard pastels, ballpoint and felt-tip pens

The initial drawing was done in ballpoint with the lines reinforced with felt-tip pen.

Water-based felt-tip pens may fade in bright light.

Wax crayons, graphite sticks and charcoal

Use a soft graphite stick to sketch the outlines roughly.

Shade in the colour with wax crayons; layering them blends the colours optically.

Charcoal was used for some of the shading.

Wax crayons, waterproof ink and ballpoint pen

A combination of dip pens with waterproof ink and ballpoint pen produced the crisp outline drawing.

The wax crayon colour can be lightly shaded or used thickly for a bold, bright effect.

Pen and wash

Traditionally, artists use black or sepia waterproof ink to create a detailed drawing to which soft washes of colour are added when the ink is completely dry. A looser, less structured effect is created by adding a drawn pen and ink outline to areas of soft colour washes after the paint has dried.

The loosely applied washes of colour, when dry, provide the background for a more controlled pen and ink drawing.

Pen and wash can be built up by continuing to add line and wash detail to create a more complex image.

Once the ink drawing is completely dry the washes are applied. Some keep within the drawn outlines, others are loose and free.

Waterproof ink, water-soluble coloured pencils and charcoal

The **NOT** surface watercolour paper gives the dry charcoal a textured effect.

The crisp edges of the ink drawing remain after the water-soluble coloured pencil has been blended with a brush.

Charcoal can also be diluted and blended with water.

Darker shaded areas of charcoal can be added after the picture has dried.

Water-soluble ink and graphite pencils

Drawings can be softened using a damp brush. Once it has dried, the outlines can be touched in to replace any crispness that has been lost.

Water-soluble ink dries to a matt finish. Waterproof shellac-based inks are more shiny.

Take care to reserve the areas that will remain white when adding the wash.

Water-soluble ink, felt-tip and ballpoint pens and graphite pencils

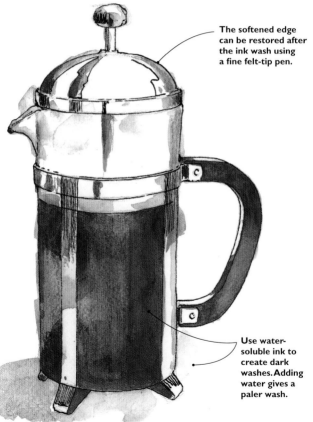

The softened edge can be restored after the ink wash using a fine felt-tip pen.

Use water-soluble ink to create dark washes. Adding water gives a paler wash.

Acrylic ink, graphite pencil or ballpoint pen

Contrast the soft shaded areas of graphite pencil on the left with the harder hatched areas using a ballpoint pen on the right.

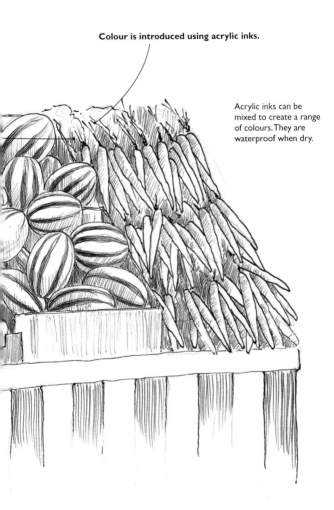

Colour is introduced using acrylic inks.

Acrylic inks can be mixed to create a range of colours. They are waterproof when dry.

Ballpoint pen and graphite pencil or soft pastels

A pencil and ballpoint pen are always useful to have ready when out sketching.

This monochrome graphite pencil sketch has been crisped up with touches of ballpoint pen.

A stronger outline sketch using a ballpoint pen was
the basis for a soft pastel study of the tractor.

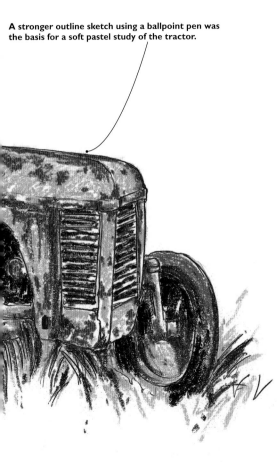

Fibre-tip and marker pens and charcoal

Fine lines using a fibre-tip pen delineate the figures in the bumper cars.

Solvent-based fibre-tip pens are relatively permanent.

A chisel-cut marker pen adds bolder touches with the final shading lightly added with charcoal.

Fibre-tip pens and waterproof ink

Using a dip pen and waterproof ink instead of charcoal for the shading makes for an altogether sharper image.

Brush pens and coloured pencils

Use a single colour brush pen with its flowing lines to make the outline sketch.

Coloured pencils shade in the colo[u]

Before using brush pens, practise doodling on scrap paper to learn how to control the marks they make and the ink flow.

Flowing lines, broad strokes and fine detail are all possible with brush pens.

Varying the pressure makes different marks and if you have several different colours they can be used in layers to create a mix.

Ballpoint and brush pens and waterproof ink

Ballpoint pen lines are uniform in width. Build up density by working them close together or by cross hatching.

A pen and ink sketch captures the action with touches of colour added with a brush pen. The shading is created with a ballpoint pen.

Both sketches were worked on a NOT surface watercolour paper.

Oil pastels and graphite sticks

To prevent the underdrawing showing through or smudging oil pastels, use an HB or harder graphite lead. If a softer lead is used, erase it leaving just a trace of the lines, particularly if light coloured pastels are to be used.

Using a soft graphite stick means the lines of the sketch combine with the oil pastel and are visible.

A canvas-effect oil paper was used as a support.

Oil pastels and felt-tip pens

A felt-tip pen gives a harder edge to the drawing. It does not combine with the oil pastel, nor does it smudge or dilute.

Pastel papers are also suitable for oil pastels.

Oil paint sticks and graphite sticks

Use a graphite stick for a soft, sketchy underdrawing.

Oil paint sticks and felt-tip pens

These luscious sticks are extremely soft and can be used for a quick sketch or to add colour to a drawing as a painting medium. They can be used on any support suitable for oil paints.

A canvas-effect oil paper support is ideal for oil sticks.

A felt-tip pen gives a more defined outline drawing.

BASIC THEORY

Drawing is a skill but it can also be learned through practice. This chapter encompasses colour theory and context, as well as exploring form, perception and shapes. Build up your knowledge of basic rules and use these methods to lay firm foundations to overcome the challenges you must learn to face in your work.

Colour terminology

Exploring colour theory is a great way to start experimenting with colour mixes. Learning about primary, secondary and tertiary colours can seem abstract and theoretical, but they will make you notice the colours around you, in nature or in manmade objects, and replicate them in your work.

Primary

Red, yellow and blue colours from which it is possible to mix all the other colours of the spectrum.

Secondary

The colours obtained by mixing equal amounts of two primary colours.

Tertiary

Browns and greys, containing all three primary colours.

Warm

Reds, oranges and yellows. In aerial perspective warm colours are said to come towards you.

Cool

Blues, greens and purples. In aerial perspective cool colours are said to appear more distant.

Tone

The light and dark values of a colour, rather than what the actual colour is.

Neutrals

A colour not associated with a hue. Includes browns, blacks, greys, and whites.

Earth colours

Paints made with naturally occurring pigments, such as umbers, ochres, and siennas, rather than chemical pigments.

Harmonious colours

A colour that sits next to or close to another on the colour wheel for example, red is near rust, which is near terracotta.

Optical colour mixing

This is created through our perception of colour. When two colours mix optically, they retain their intensity.

Glazing/scumbling

Dragging a dense or opaque colour across another colour creating a rough texture.

Shade

Using a mixture of black combined with a colour to make it darker. The opposite of shade is tint.

Hue

The name of any colour found in its pure state in the spectrum or rainbow, or that aspect of any colour.

Tint

Combining white with a colour to make it lighter. Tint is the opposite of shade.

Transparency

The technique of using only transparent water media, as opposed to opaque paints such as acrylics etc.

Opacity

The quality of being opaque. The power of a pigment to cover the surface to which it is applied.

Colour wheel

The colour wheel is a useful reference device that is based on the spectrum. Cool colours are on one side and warm colours on the other. Colours next to each other harmonize well, while colours on opposite sides of the wheel are referred to as 'complementary'.

It is worthwhile creating your own colour wheel using three primary colours and then mixing them to create the secondary and tertiary colours between them, as this helps in understanding how a colour wheel works. Make sure you label the mixes so that you can re-create them later.

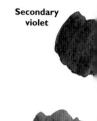

Secondary violet

Tertiary blue-violet

Primary blue

cool colours

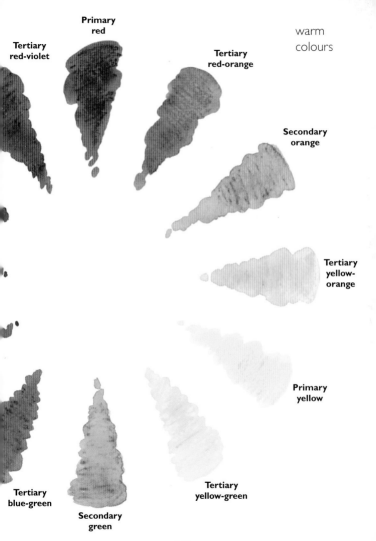

Tertiary red-violet

Primary red

Tertiary red-orange

warm colours

Secondary orange

Tertiary yellow-orange

Primary yellow

Tertiary blue-green

Secondary green

Tertiary yellow-green

265

Primary colours

The three primary colours are red, blue and yellow. They cannot be made by mixing two or more colours together. A picture made from primary colours is bright and cheerful, if perhaps a little unsubtle.

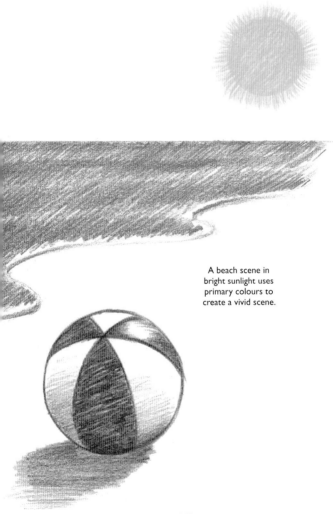

A beach scene in
bright sunlight uses
primary colours to
create a vivid scene.

Secondary colours

Mixing each of the two primary colours together produces the three secondary colours:

• Red mixed with yellow produces orange

• Yellow mixed with blue produces green

• Blue mixed with red produces purple

Like the primary colours, secondary colours are divided into warm and cool.

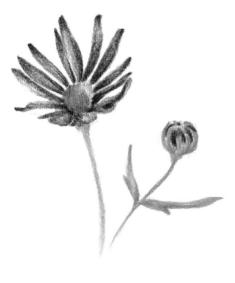

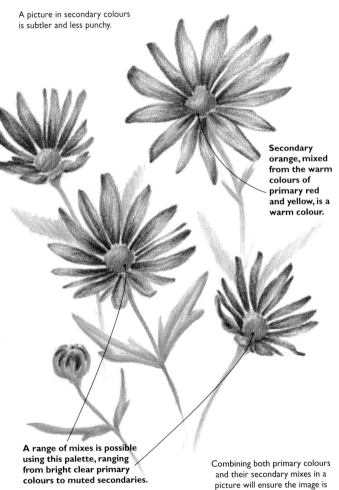

A picture in secondary colours is subtler and less punchy.

Secondary orange, mixed from the warm colours of primary red and yellow, is a warm colour.

A range of mixes is possible using this palette, ranging from bright clear primary colours to muted secondaries.

Combining both primary colours and their secondary mixes in a picture will ensure the image is 'harmonious'.

Tertiary colours

Mixing one primary and one secondary colour, or all three primary colours, makes the six tertiaries set between the primaries and secondaries on the colour wheel. A landscape or still life created using tertiary colours is subtle, varied and very true to life.

Varying the amount of each colour in the mix increases the range of shades you can create.

Three of the tertiaries – blue-violet, red-orange and yellow-orange – are on the warm side of the spectrum.

The other three – yellow-green, blue-green and red-violet – are cool colours.

Harmonious colours

Between red and yellow on the colour wheel are the tertiaries and secondaries. Primary red is followed by tertiary red-orange, a mix of primary red and secondary orange. This is followed by secondary orange, a mix of two primaries red and yellow. Lastly tertiary orange-yellow is created from a mix of primary yellow and secondary orange. The contrasting primaries of yellow and red are linked by these harmonious secondary and tertiary colours, which will work well in a picture.

Red and blue have been mixed in different proportions to create soft pinks, purples and mauves.

Choosing two colours that lie next to each other on the colour wheel ensures they are harmonious as they are a product of mixing the same colours.

Complementary colours

Choosing two colours that are opposite each other on the colour wheel ensures a contrast is set up. The colours set side-by-side intensify each other but when they are mixed they become more subdued.

Two complementaries set alongside each other make each of the colours look stronger. By mixing two complementary colours, a useful range of neutral browns and greys is created.

Primary red is the complementary of green, which is mixed from two primary colours, blue and yellow.

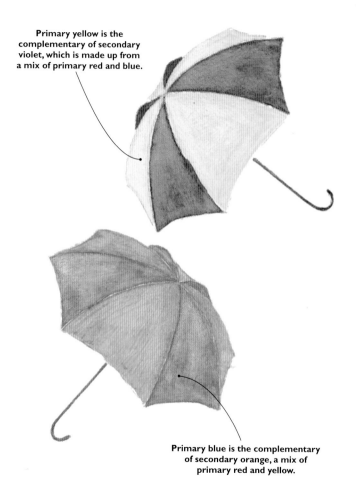

Primary yellow is the complementary of secondary violet, which is made up from a mix of primary red and blue.

Primary blue is the complementary of secondary orange, a mix of primary red and yellow.

Hot and cool colours

Red, orange and yellow are called hot colours while green, blue and mauve are cool colours, but these are simplified definitions. There are cool reds, such as the crimson reds, warmer blues, such as ultramarine, and cool yellows, such as lemon yellow.

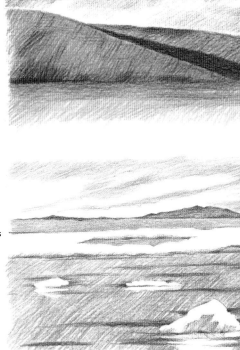

The use of warm colours brings this hot dry scene forward.

A cool colour palette increases the sense of distance.

Cool colours are recessive while warm colours advance into the foreground. Hills in the background often look blue, so using this colour creates an effect of being far away.

Mixing wet colours

Paints can be transparent or opaque. Transparency affects the mixing of the colour and its use in washes. By overlaying transparent paints, a range of delicate variations of colour can be achieved. How they are used also affects the outcome.

With wet on wet, the colours bleed into each other.

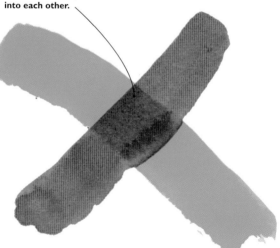

Experimenting with
different colours
and techniques helps
to understand how
they work.

**Wet on dry ensures
the colour beneath
remains crisp.**

Always label the colours you
have used and file them for
future reference.

Mixing dry

Conté and coloured pencil

Soft pastel and coloured pencil

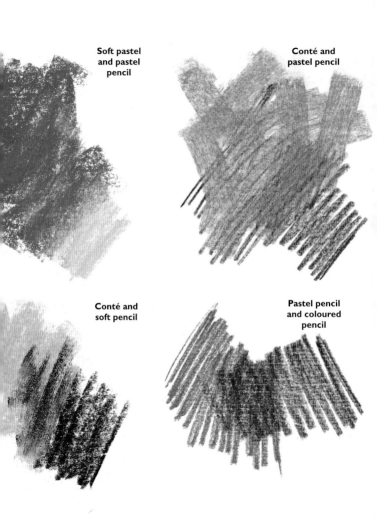

Soft pastel and pastel pencil

Conté and pastel pencil

Conté and soft pencil

Pastel pencil and coloured pencil

Mixing dry

**Hard pastel and
oil paint stick**

**Hard pastel and
oil paint stick**

**Hard pastel
and oil pastel**

**Oil paint stick
and oil pastel**

**Hard pastel
and oil pastel**

**Oil paint stick
and oil pastel**

Optical colour mixing

Colours are affected by their surrounding colours. This is called optical colour mixing and it can be exploited in several ways. Simply placing small amounts of colour side-by-side will, when viewed from a distance, create a third colour. For example, dots of blue and yellow placed close together in a small area will appear green at a certain distance.

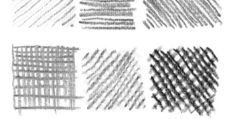

Broken colour and glazing

Stippling, hatching, cross-hatching and dry brushing two or more colours together creates a complex coloured surface which can be used to great effect.

Glazing, which is also called scumbling, is the laying down of a transparent colour over another colour or a coloured support. The colour beneath is not completely covered and the two colours blend to create a third.

Tonal values

Tone is often more important to an image than colour, and using more tones and less columns is sometimes the most effetive key to success.

A range of soft graphite pencils was used for the mono tiger.

Tones can be created by mixing colours, adding water, adding white, grey or black to a mix or by using a complementary colour to darken the mix.

Understanding the relationship between dark and light tones makes it easier to choose the correct colours when translating an image into colour.

Aerial recession

Aerial recession creates the illusion of depth, or recession, in a drawing by modulating colour to simulate changes effected by the atmosphere on the colours of things seen at a distance.

As the eye travels further into the distance the colours become cooler and the details less define

The colours in the foreground are warmer with the details clearer and more defined, showing greater contrast.

Tone is also important: make sure the darker tones are used in the foreground with the paler tones kept in the background.

In the far distance the overlapping hills are in the cooler graded shades of mauve and blue.

Single vanishing point

If you could stand looking at a straight road disappearing into the distance, the parallel lines seem to join at the horizon at what is called the vanishing point. The horizon, where the land meets the sky is at eye level for the viewer.

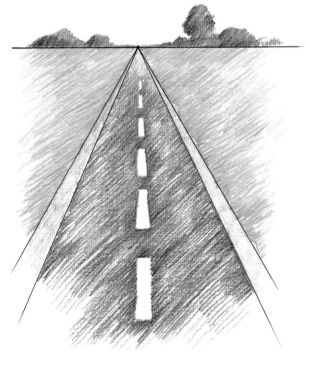

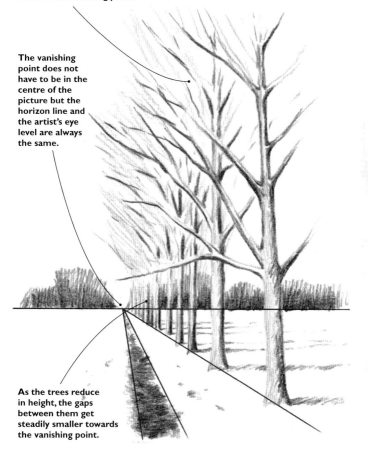

If the road were lined with trees the tops of the trees would also run along a perspective line to meet at the vanishing point.

The vanishing point does not have to be in the centre of the picture but the horizon line and the artist's eye level are always the same.

As the trees reduce in height, the gaps between them get steadily smaller towards the vanishing point.

Two vanishing points

If you look at a corner – whether it is of a building or inside a room then this will involve two-point perspective with two vanishing points each meeting on the same horizon line.

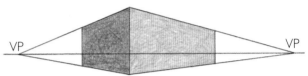

Lines drawn along the roof and base of the building when extended meet each side at vanishing points on the horizon.

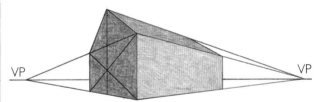

A hipped roof adds additional perspective lines.

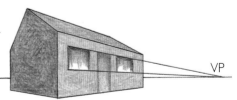

Lines drawn along the tops and bottoms of windows also converge.

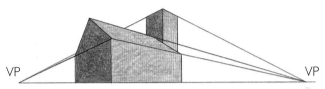

A building with a high horizon line, seen from below.

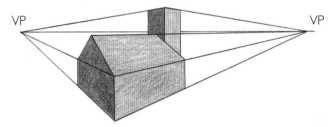

A building with a low horizon line, seen from above.

Multiple-point recession

Each of these buildings has its own set of
perspective lines meeting on the horizon
at three different vanishing points.

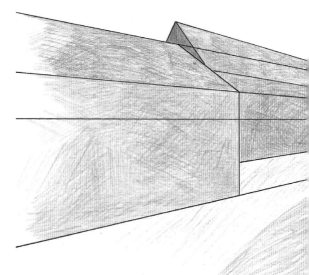

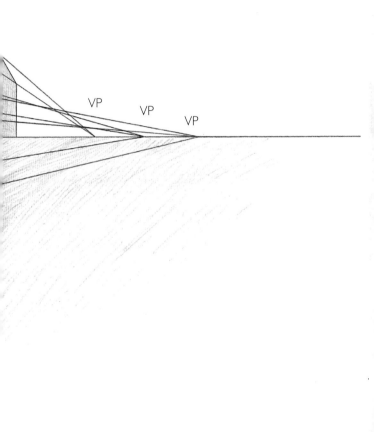

VP VP VP

Linear recession

In a cloudscape the larger clouds appear spaced out at the top of the picture.

As they recede towards the horizon line they get smaller and closer together, giving the scene depth.

Stronger colours used for the foreground clouds gradually fade to the horizon, reinforcing the depth.

The perspective lines simply show that the clouds converge towards the vanishing point.

VP

297

Overlapping forms

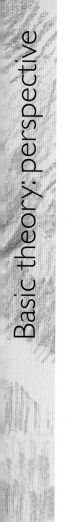

A sense of depth is created from the brightly coloured tree, as well as the detailed shadows of the overlapping tree.

The path running between the trees, converging at the horizon leads the eye into this picture.

This tree picks up the colours of the foreground, leading the eye further into the scene.

Rule of thirds

Dividing up a picture either horizontally or vertically into three and then placing the key elements of the picture where the lines intersect is visually pleasing.

The horizon line is set two-thirds of the way up the picture with the group of trees set two-thirds over to the right where the lines intersect.

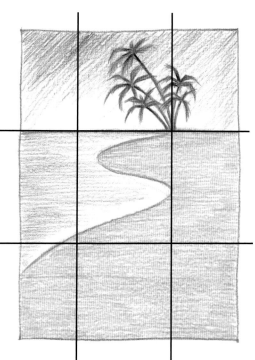

The same scene drawn with the horizon line bisecting the picture just above the halfway point and the trees centrally placed lacks dramatic impact and gives very little visual satisfaction.

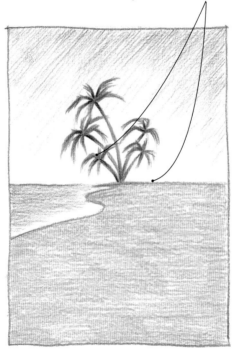

Counter change

Using contrast holds the attention of the viewer and draws the eye to the focal point.

Contrasting the bold tree trunk with the smaller, delicate bench gives the picture visual impact.

Dark and light counter change.

At its basic, counter change is using light against dark and large against small.

Deep shadows from the tree and along the hedge make the bench, set in an area of bright sunlight, the centre of interest in the image.

Using positive shapes

The positive shapes of these skyscraper buildings produce the negative shape of the skyline, a way of describing the space between solid objects.

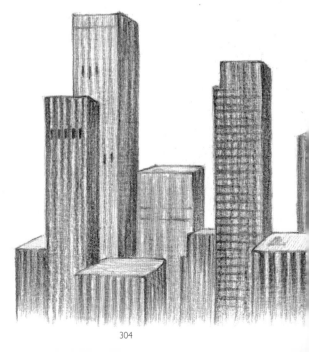

Positive shapes are usually the central, featured elements.

Using negative shapes

Try drawing the negative shapes of an image, such as the spaces between the branches of a tree rather than the tree itself. You will find that you concentrate on what you see rather than trying to capture the exact likeness.

A solid piece of subject occupies space, and makes the space around it come to life.

Single focal point

The focal point here is the shell, which has been placed according to the rule of thirds (see page 300). To lead the eye to the focal point, a diagonal line of pebbles runs up to the shell from the bottom left-hand corner.

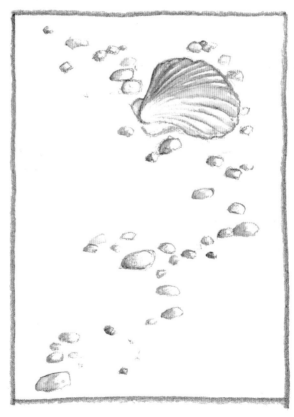

Two or more focal points

In this picture there is no obvious hierarchy between the three shells and therefore no particular focal point, meaning the eye jumps from shell to shell, unable to see the image as a whole.

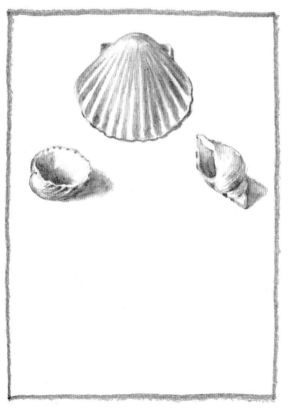

Creating form

Form is a basic, three-dimensional figure – a simple outline drawing such as this rabbit, can capture the basic form and characteristics.

Creating volume

Adding volume gives you basic form a realistic
appearance and impression of depth.

Build up the shapes using gradations
of tone and paying particular attention
to the way the light falls on the subject
to create dark shadows and depth.

Shapes

Within a composition, try to avoid including any symmetrical shapes formed by objects, group of objects, or blocks of a similar tone.

To help find the perfect composition, try using L-brackets to isolate elements in a scene.

Cropping in tightly concentrates on the dramatic architecture of the Sydney Opera House leaving out the distractions of the surrounding harbour scene.

Lighting

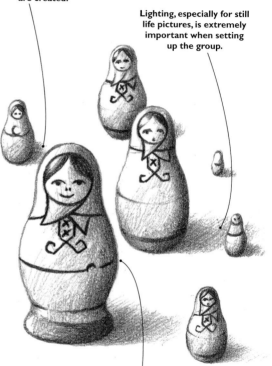

With the light coming from the left or right, interesting shadows are created.

Lighting, especially for still life pictures, is extremely important when setting up the group.

The dark shading contributes to the form and solidity of the dolls.

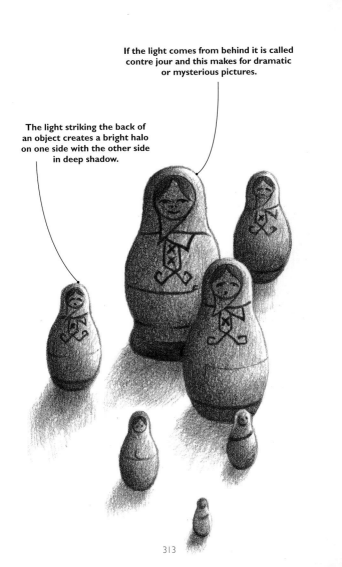

The light striking the back of
an object creates a bright halo
on one side with the other side
in deep shadow.

If the light comes from behind it is called
contre jour and this makes for dramatic
or mysterious pictures.

Formats

In addition to the traditional portrait and landscape formats, there are a variety of picture shapes to choose from. This sketch of St Basil's Cathedral in Red Square has been treated in a variety of ways.

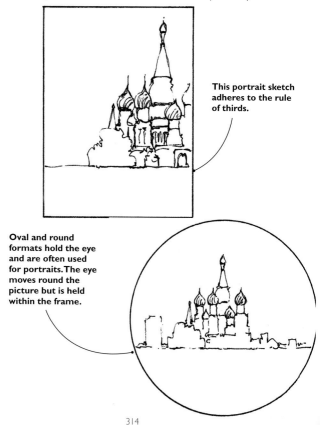

This portrait sketch adheres to the rule of thirds.

Oval and round formats hold the eye and are often used for portraits. The eye moves round the picture but is held within the frame.

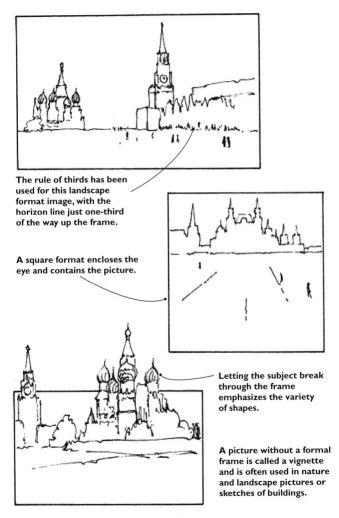

The rule of thirds has been used for this landscape format image, with the horizon line just one-third of the way up the frame.

A square format encloses the eye and contains the picture.

Letting the subject break through the frame emphasizes the variety of shapes.

A picture without a formal frame is called a vignette and is often used in nature and landscape pictures or sketches of buildings.